BLACK AMERICA SERIES

AFRICAN-AMERICAN ENTERTAINMENT IN BALTIMORE

Rosa Pryor-Trusty (above) and Tonya Taliaferro (below) are co-authors of *African-American Entertainment in Baltimore*.

BLACK AMERICA SERIES

AFRICAN-AMERICAN ENTERTAINMENT IN BALTIMORE

Rosa Pryor-Trusty and Tonya Taliaferro

ARCADIA
PUBLISHING

Copyright © 2003 by Rosa Pryor-Trusty and Tonya Taliaferro
ISBN-13 978-0-7385-1513-7

Published by Arcadia Publishing
Charleston, South Carolina

Printed in the United States of America

Library of Congress Catalog Card Number: 2003100300

For all general information contact Arcadia Publishing at:
Telephone 843-853-2070
Fax 843-853-0044
E-mail sales@arcadiapublishing.com
For customer service and orders:
Toll-Free 1-888-313-2665

Visit us on the Internet at www.arcadiapublishing.com

Contents

Acknowledgments 6

Introduction 7

1. Something to Do 9

2. Elbow Benders 21

3. The Sphinx Speaks 27

4. The Flame of Fame 31

5. The Local Chittlin' Circuit 47

6. The Marquees 79

7. I Book It, You Play It 89

8. Taking Care of Business 99

9. The Meeting Is Called to Order 109

10. Showing Off 117

11. The Word on the Street 123

ACKNOWLEDGMENTS

The authors extend their warmest, sincerest appreciation to the The Peale Museum, Chevy Chase Bank, Hoppy Adams, The Maryland State Archives, the *Baltimore Sun*, and Tim Watts.

Mrs. Pryor-Trusty
I offer heartfelt gratitude to my dear sweet husband, William "Shorty" Trusty. Thanks to Jackie Lanier, who shared historical information and words of wisdom for *The Avenue*, when I started that book over 10 years ago. I also thank my former boss, Joy Bramble, publisher of the *Baltimore Times*, who taught me all I know about the newspaper business and encouraged me to do this book; Charlie and Randy Tilghman, owners of the Sphinx Club, who opened their archives to me; journalist extraordinaire James "Biddy" Wood, a very special friend and mentor; and Ethel Ennis, Earl Arnett, Fuzzy Kane, and Henry Sampson, all of whom shared their books, photos, and information. Thanks to *The Afro American* Newspaper, Benjamin Pope, Andrea Street, Beverly and Zack Mosby, Dr. Donna Hollie, Carlos Johnson, Joyce Gates, Jacqueline Taylor-Johnson, Left Bank Jazz Society, Inc., Arch Social Club, Marty Paulson, and Victor Walters.

I dedicate this book first to my husband for his love, patience, and understanding. While I was trying to complete this book, he indulged my every need, acting as butler, chauffeur, masseur, chef, proofreader, and researcher. I also dedicate this to Biddy Wood, my dear friend and mentor, who ensured that the words from my pen were correct and positive. This is dedicated also to the late Walter Carr Sr., owner of the *Nightlife Magazine*, who supported and encouraged my writing endeavors; to the late Charlie Tilghman, who gave me the history of the Sphinx Club in pictures and challenged me to keep the Sphinx Club and other Pennsylvania Avenue night club legacies alive; and finally to William "Willie" and Victorine Adams, and Raymond Haysbert, my dear friends who gave me support, love, and encouragement when I started this book.

Ms. Taliaferro
I dedicate my deepest love and gratitude to my grandmother, Ms. Louise Alston, for her wisdom, guidance, and knowledge; to my mother Mrs. Brenda Armstead, for her unwavering trust and support through all of my stumbling and fumbling; and to Mrs. Pryor-Trusty for being exactly what she is, a phenomenal woman! This project would NOT have been completed if not for your perseverance, reassurance, and motherly love. I give love to Brother Jamal Muhdi-Bey and Dr. Charles Simmons of Sojourner Douglas College and the Left Bank Jazz Society for living the music, loving the arts, and understanding the importance of archiving our history; to Mr. Bill Proctor for knowing a good project when he sees one and contributing freely and wholeheartedly; to my fairy godfather, the legendary Hoppy Adams for being my protector and keeper when no one else would; to my father and stepmother, Mr. and Mrs. Vernon and Vanessa Taliaferro, for being there when I really need you and always being my number one fans; and to Ms. Jean Thompson for making the *Baltimore Sun* a light among the light. I also send thanks to Mr. Carlos Johnson, a dynamic musician; to Mr. James "Peanut" Saunderlyn for telling it like it is; to Roland Campbell and Roc Realty for feeling the honor of inclusion; to Dennis Chambers for making his word his bond even though he was a million miles away; to Mrs. Virginia Woodley for holding fast to our legacy and knowing that our soul is NOT for sale; to Mr. David L. Coleman of Coleman Music Researchers for being a walking music encyclopedia; and to Mr. and Mrs. Jeff and Dorothy Pitts and Ms. Evelyn Moody, soldiers in the community, for keeping the youth on point. To everyone who assisted in this project, you have all of my love and appreciation.

I breathe the fire of our heritage into my daughter, Nanyamka Akilah Taliaferro. Like this history, you are timeless, endless, and beautiful. I charge you to burn and blaze new galaxies, like that which has been forged for you. May you always know who and what you are and always, always hold fast to the fire!

INTRODUCTION

At present, our economy is experiencing so many shades of red: the falling stock market, record unemployment, massive layoffs, corporate scandals, and collapsing retirement funds. During these trying times, our most soothing relief comes through understanding our history, seeing that our perseverance through the present and our forging of the future begins with the wisdom of our past pilgrimages. The fruits of our lives are our arts, our music, our theater, and our good times. The roots of these are where the folks gather to sing, to play, to share, to inspire, to create, and *re-create*. We return to the roots, to the blackest part of the soil, the oil of our existence. Here we are reminded that no matter how in the red we may be, our artistic heritage sustains and remains the essence that keeps us in the *black*, rich beyond bounds.

For Baltimore, this is undoubtedly the gospel truth. Baltimore's very rich arts and entertainment history started during the 1920s with The Royal Theater located on what was the city's main entertainment artery, Pennsylvania Avenue. The Royal, established in 1921 as the Douglas Theater, played host to a variety of great entertainers such as Ethel Waters, Louis Armstrong, Fats Waller, Louis Jordan, Nat King Cole, Redd Foxx, the Temptations, the Supremes, and James Brown.

Its fame made it a crucial part of the Chittlin' Circuit, the network of major American cities' theaters, concert halls, and lounges where black entertainers displayed and honed their crafts as musicians, singers, dancers, actors, and comedians. A facet of this entertainment network also included nightclubs, bars, and after-hours havens. During its heyday of the 1930s to the 1960s, Baltimore had no shortage of these hot-spot hang-outs gracing the corridor of Pennsylvania Avenue. Established in 1949, the Casino Club was owned by the legendary Little Willie Adams and proved a staple for Baltimore's music and arts scene. After a show at the Royal Theater one might find Billie Holiday and friends relaxing at the Casino with a strong drink, a healthy helping of fried chicken and potato salad, and carrying on stimulating conversation about the night's performances and the goings-on backstage. Baltimore was the fort for a hodgepodge of these African-American clubs, like Gamby's, the Sphinx Club, Club Frolics, the Town Bar, the Avenue Bar, Alhambra, Wagon Wheel, Bam-Boo Lounge, York Hotel, Comedy Club, Bucks Bar, the Spot Bar, the Millionaire Club, Wonderland, the Golden Pen, Red Fox, Crossroads, O'Lee Land Club, Club 2701, Dreamland, Ubangi, the Vilma, and Club Tiajuana.

The Sphinx Club arguably may have been one of the first "black members only" clubs/lounges of its kind in the United States. Established by Mr. Charlie Tilghman in 1946, the Sphinx Club afforded its members an elite status with all the fringe benefits of its offshoot organizations like the Young Pharaohs, the Ladies of the Sphinx, the Sphinx Softball and Oldtimers Basketball Teams, and the Sphinx Bowling Club. The club's ambiance, live music, fine food, charismatic characters, smooth wine and spirits, lively parties, lovely ladies, and the creativity of its dynamic founder intoxicated the senses. Mr. Redd Foxx held the Sphinx dear to his heart as one of his favorite nighttime mainstays.

Baltimore's homegrown local musicians made a name for themselves as the backbone of the Chittlin' Circuit, and some acquired international fame. Mr. Bill Kenny, the often-imitated voice of the Ink Spots, was born in West Baltimore and enjoyed international success as a pioneering lead crooner. Sonny Til and the Orioles, the Ink Spots' successors, were born and bred in Baltimore and laid groundwork for the pantheon of black music gods and goddesses. They formulated the "secret sauce" for the main ingredient of every doo-wop and R&B male vocal group since their inception in 1948.

Baltimore and its surrounding areas definitely blazed trails for black radio personalities. Historic radio icon Hal Jackson made his radio debut in 1939 on WOOK at Howard University in Washington, D.C. and shortly thereafter challenged the airwaves on WANN-Annapolis, and WSID in Baltimore. Mr. Jackson reared legendary Hoppy Adams, the creator of the nationally acclaimed "Bandstand on The Beach" concert series, which was broadcast live at Carr's Beach in

Annapolis. Hoppy, star of WANN AM and FM radio, made a name for himself and many others in the entertainment industry. His radio show was enjoyed as far away as Ohio, thanks to WANN's 50,000 watts.

During Baltimore's heydays, businesses and organizations thrived. The Charm Center, a women's fashion store owned by Ms. Victorene Adams, wife of "Little Willie" Adams, catered to the same entertainers that played at the Royal and Regent Theaters. The Left Bank Jazz Society (LBJS), a pioneer jazz organization, drew all the great jazz legends to the city, such as Count Basie, Dizzy Gillespie, Sonny Stitt, Stan Getz, and Jimmy Heath, and nurtured others into notoriety. Created by a group of young jazz connoisseurs, LBJS regularly premiered concerts at the Famous Ballroom on Charles Street in midtown Baltimore. Their dedication was and still is a manifestation of a love for the music—nothing more, and nothing less. Marching bands like the Baltimore Westsiders and the Firebirds could be heard practicing three times each week to prepare for regular weekend parades. These provided opportunities for young African-American marching mavericks to show off their magnificent moves down the black tar of Baltimore's city streets.

In this volume, Baltimore's number one entertainment columnist, "Rambling Rose" (Rosa Pryor-Trusty) has gathered a breathtaking album of frozen moments that capture the essence of Baltimore's entertainment scene at its liveliest. She and co-author Tonya Taliaferro piece together a history that demonstrates the passion, the pain, the pleasure, and the perseverance of a people who love, create, and dominate our music and entertainment culture all over the world. Mrs. Pryor-Trusty's collection of snapshots were lovingly donated by people who share her vision and passion. They are a testimony of our essence—the essence of our souls that we freely and wholeheartedly share with the world community.

Designed as a photographic diary that illuminates Baltimore's African-American arts history, *African American Entertainment in Baltimore* celebrates a time in our past that enforced expectations of excellence and captured the highest quality of people. This composition sings a harmony, a melody in time when African-American men and women dressed to the nines and stepped out in full fashion adhering to the code of ethics developed by the Pennsylvania Avenue Strip. It was a time when there was always something to do; a time when one could enjoy 15 minutes of fame as an *elbowbender* or a *starmaid*; a time when you knew the Sphinx spoke even if you were not a member. Most importantly, it was a time when African Americans headlined the marquees right in their own neighborhoods and reveled in the love and support of their community. Turn the pages and embrace the history of a people whose past, present, and future are right now. Welcome to who and what you are.

Two
SOMETHING TO DO

It was all about "something to do." Where were we going to go before the show, after the show, or for the show? What were we going to eat? What were we going to drink? Who were we going to see? This chapter shows the most popular nightspots of Baltimore, located on its main entertainment artery, Pennsylvania Avenue. It features the men and women who envisioned ownership of an elegant watering hole, the edifices, and their staffs of starmaids—yes, starmaids, not barmaids, for it was understood that they were just as popular if not more so than the club owners or famous entertainers who stopped by. Transport yourself back to the Bamboo, Gamby's, and the Casino, and have a drink on us.

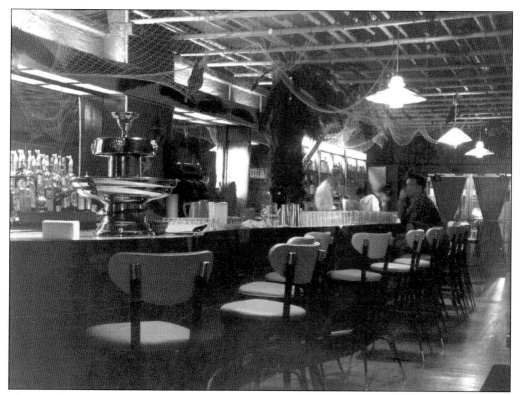

The Bamboo Lounge was located at 1426 Pennsylvania Avenue, a more quiet section of the street nicknamed "the Avenue." Owner Ted Carver created an exotic ambiance, serving international dishes and outfitting his staff with intercontinental attire.

This is a Bamboo Lounge advertisement as seen in a local club magazine.

These Bamboo Lounge starmaids of the early 1960s are dressed in oriental attire.

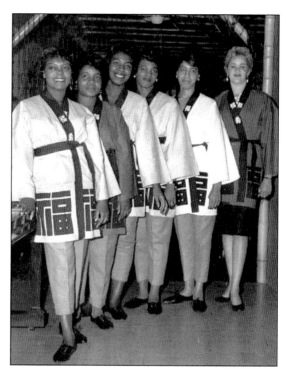

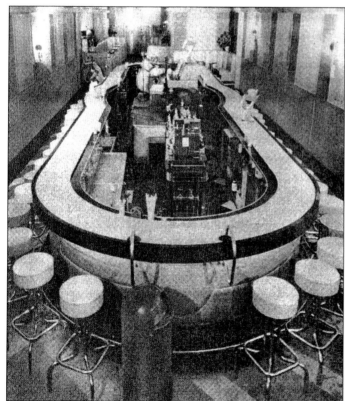

The Comedy Club was established by the late Ike Dixon, a drummer and founder of a traveling jazz band in 1920. He opened the Comedy Club in 1934 at 1414 Pennsylvania Avenue. Many national stars from the New Albert Hall, the Savoy, and the Strand performance venues gathered here after showtime to party.

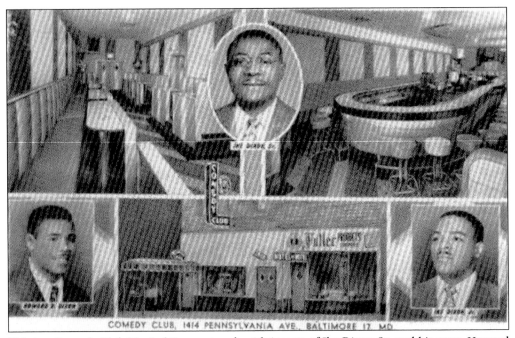

This is a Comedy Club Musical Bar postcard, with inserts of Ike Dixon Sr. and his sons, Howard and Ike Jr.

This is a picture of a local night club, the last place Billy Holiday performed in Baltimore.

A handsome couple poses in elegant attire during a photo session at Clinton's Photography Studio on the Avenue. (Courtesy of the Clinton Studio.)

These fashionable ladies are partying in 1964 at Buck's Bar Breakfast Show, located in the 1100 block of Pennsylvania Avenue at the corner of Hoffman Street. Pictured from left to right are Doris, Roxy, Apple, and Ann (last names unknown).

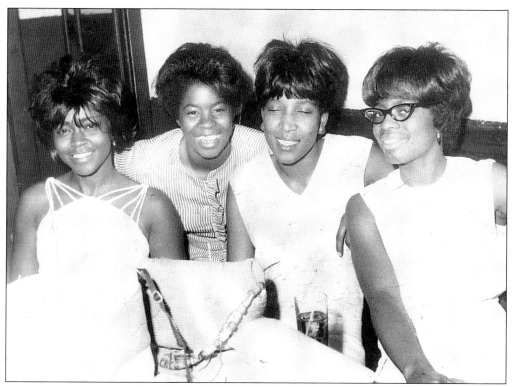

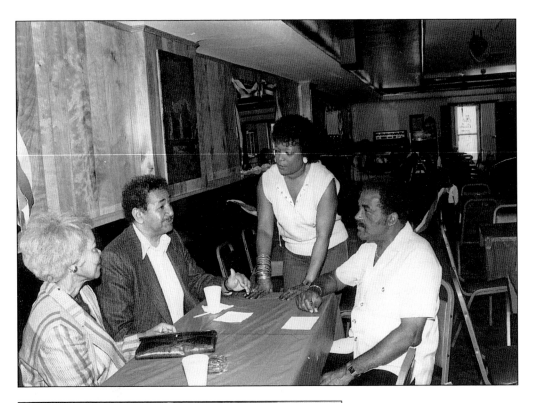

Seated in the Club Casino from left to right are Mr. and Mrs. Raymond Haysbert, Rosa Pryor (standing), and Herb Brown in 1979.

Standing from left to right in the Club Casino Lounge are Roy Hamilton's manager, an unidentified woman, William "Willie" Adams (owner of the Club Casino), and Roy Hamilton, who clowns around for photographer Clinton.

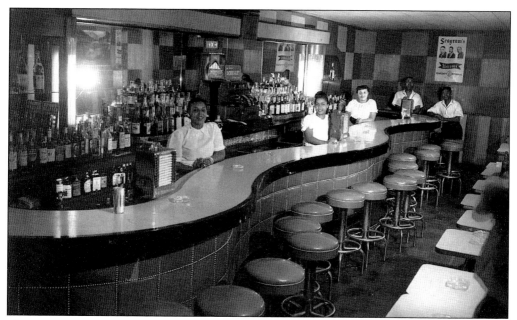

This scene is inside the Club Casino on Pennsylvania Avenue in 1949; it still sits on the 1500 block of Pennsylvania Avenue today. (Courtesy of The Henderson Collection; Photograph of Peale Museum, Baltimore City.)

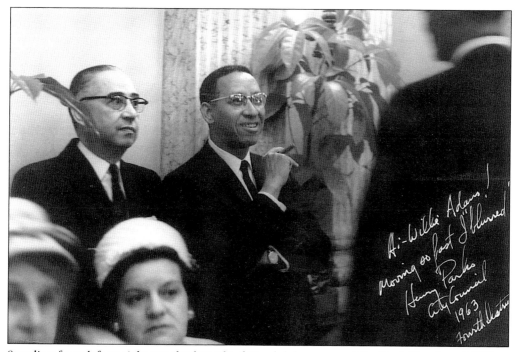

Standing from left to right are the late Lloyd Randolph, owner of the York Hotel, and William "Little Willie" Adams, two of Baltimore's outstanding businessmen. Little Willie could be called the "Rockefeller of Baltimore," for he is a business legend in the city. As owner of a multitude of companies, his most famous venue was, of course, the Club Casino. They are pictured in 1963.

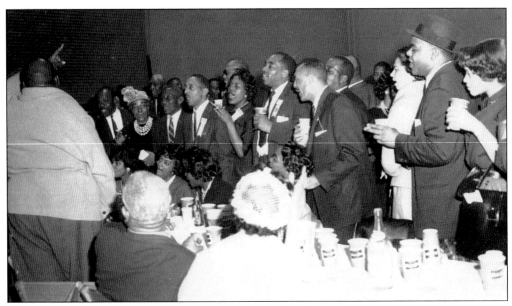

This party at the Winchester Armory was held in the 1950s following a basketball game between the Sphinx Club and the Philadelphia Old Timers. The Winchester Armory is an Army National Guard Reserve Building used as a dance hall for cabaret and social functions. It still stands in the same location today at Winchester Street and Braddish Avenue.

This is a view inside Gamby's, the club where Redd Foxx fine-tuned his stand-up routine. Comedian Redd Foxx became the club's master of ceremonies in 1942. He ventured to Baltimore after jobs became scarce in New York City. Pictured here are some of Redd Foxx's friends, Gamby's owner Chandler Wynn (middle) and two unidentified ladies.

Walter Rouse (left), one of the owners of Gamby's on Pennsylvania Avenue, hosts a special affair at the club for singing star Roy Hamilton (third from left) and living legend and businessman William "Little Willie" Adams (second from right). With them are four of Walter's Starmaids.

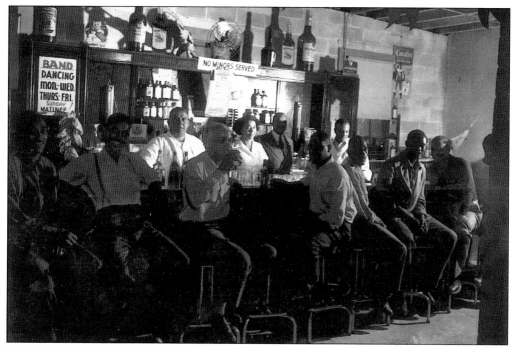

The famous Moonglow Night Club was located in the 1600 block of Pennsylvania Avenue in the Penn Hotel. This picture was taken in the 1930s.

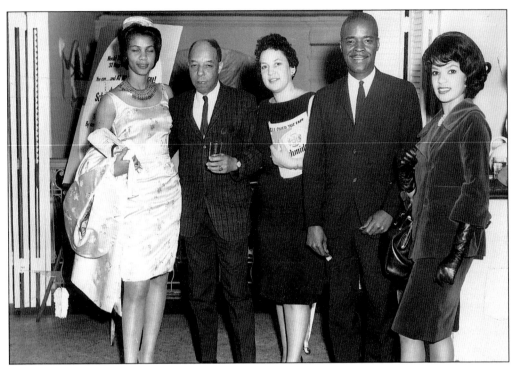

Patrons of the Avenue are seen here, including Walter Brown and his guests "Harry the Horse" and three lovely ladies!

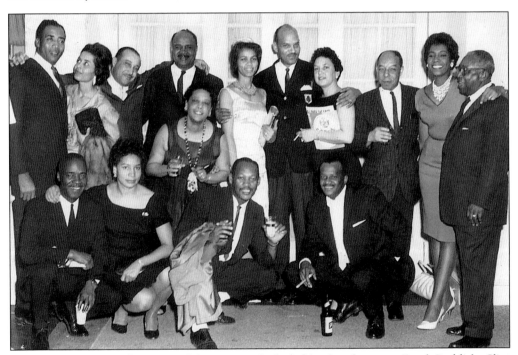

This is another view of patrons of the Avenue. Included in the photo are Frank Reddish, Clint Jenkins, and Bill Bell.

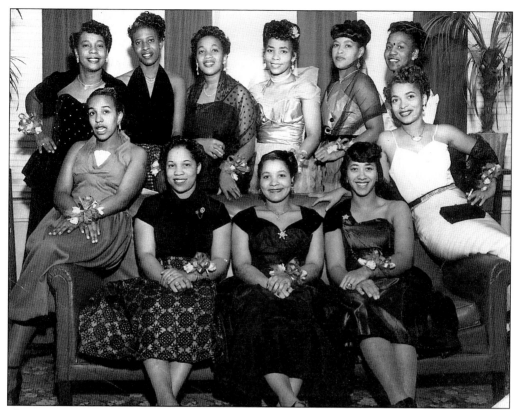

This picture features members of a social club posing at a private social event.

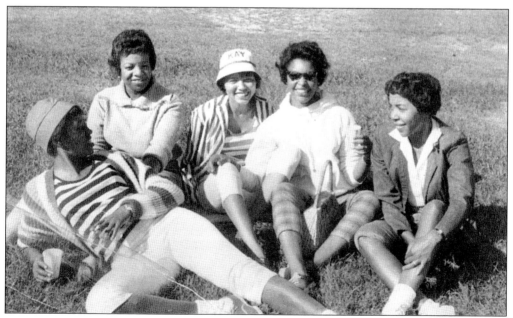

Pictured here are some well-known starmaids. From left to right are Jean Carwile, Francine Warden, Beta Dotson, Gigi Jackson, and Jenny?.

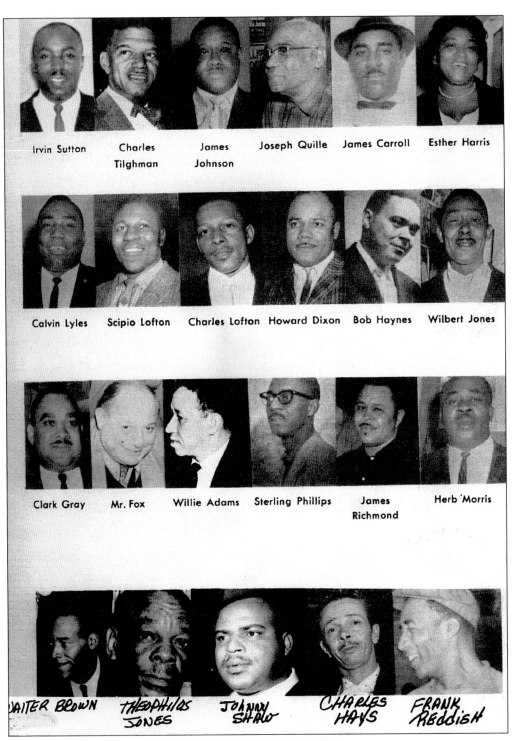

Irvin Sutton Charles Tilghman James Johnson Joseph Quille James Carroll Esther Harris

Calvin Lyles Scipio Lofton Charles Lofton Howard Dixon Bob Haynes Wilbert Jones

Clark Gray Mr. Fox Willie Adams Sterling Phillips James Richmond Herb Morris

Walter Brown Theophilos Jones Johnny Shaw Charles Hays Frank Reddish

Here is a showcase of some of Baltimore's club owners in 1950.

Two
ELBOW BENDERS

An elbowbender, now what does that mean? If you were a patron in any of the "something to do's," then you would more than likely have a glass of spirit in your hand. Maybe you were the speedy shot shooter, or the slow sipper, or the straw stirrer, or the beer guzzler—no matter, your elbow was bent to hold the crystal and swallow its elixir. Hence, the term "elbowbender" describes the patrons, the locals, and the out-of-towners who frequented Baltimore's night spots.

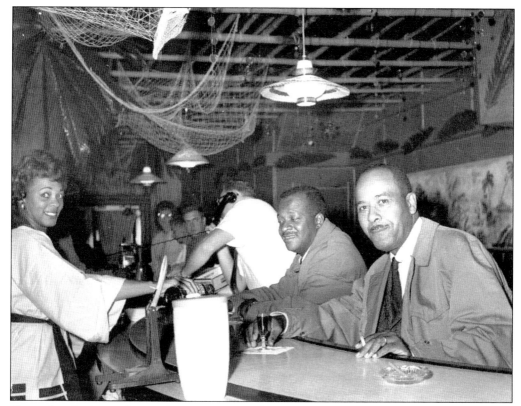

Pictured at the bar at the Bamboo Lounge are elbowbenders Bill Bell and Charlie Thomas.

Regular patrons enjoy themselves at the Birdcage Bar and Lounge, located on the corner of North Avenue and Chester Street in East Baltimore.

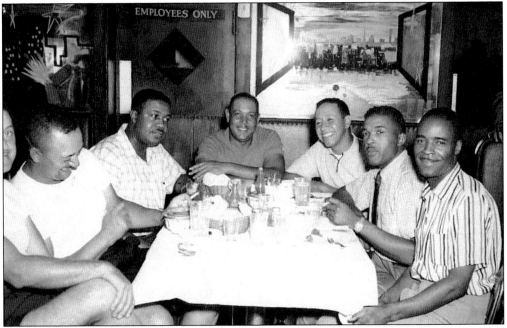

Willie Adams (third from right), seen smiling at the far end of the table, is pictured among friends at his club.

Friends enjoy their cocktails at Jackie's Tavern in 1980. Seen from left to right are John McCutchen, Major Eugene Brown, Joe Parker, Bernard Smith, and Vernon Hutchins.

Pictured here is the Elgin Lounge on the corner of Elgin Avenue and Monroe Street. Patrons are checking out the legendary Sonny Til and the Orioles show in 1980.

Elgin Lounge patrons are seen bending elbows. The bar was located on Monroe Street and Elgin Avenue.

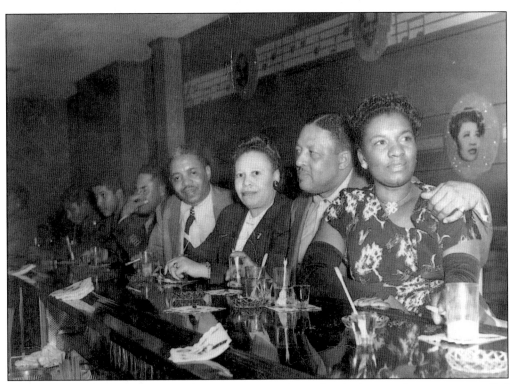

Juanita Taylor (far right), owner of a restaurant on Pennsylvania Avenue that everyone called "Mom's," is pictured with her husband at the Frolic Bar on the corner of Lafayette and Pennsylvania Avenues in 1950.

Ladies are hanging out and waiting to enjoy their cocktails at Club Casino.

Here at The Saloon, the masters of the elbowbenders are Harvey, Ike, and Charles and an unknown buddy.

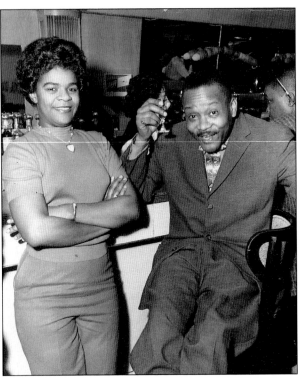

This unidentified gentlemen raises a toast to famous barmaid Ophra at the Sphinx Club.

More elbowbenders enjoy cocktails at the Sphinx Club.

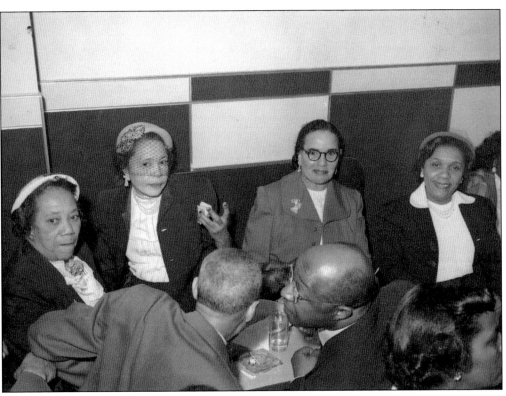

Three

THE SPHINX SPEAKS

The Sphinx Club, established in 1946 by Charlie Tilghman, deserves a chapter to itself because it was the place to be. Mr. Tilghman mastered the art of club promotion by first making his club "members only" and therefore elite. A gifted party planner, his themed events became fundamental parts of Baltimore nightlife. Furthermore, the Sphinx lasted longer than any other club as a major nightspot. The Sphinx maintained its identity well into the 1990s. Its offshoot organizations, like the Young Pharoahs, the softball and bowling clubs, and the basketball and softball teams added spice to the club's overall appeal. Mr. Tilghman's business acumen and clever wit saw him make strides as supermarket mogul as well. Super Pride markets (initially established as Jet Foods) was one of several successful business ventures he founded.

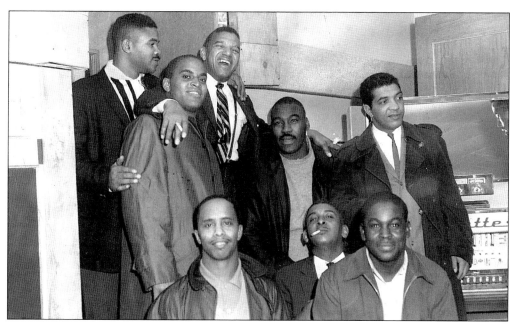

This is the Sphinx Club, "Where old friends meet and new friends greet." Sphinx Club owner Charlie Tilghman (third from left) is pictured with his arms around Baltimore Colts football stars Johnny Sample (to the left of Charlie) and Eugene "Big Daddy" Lipscomb (to the right of Charlie), Eggie Hawkins, Bill Hayden, and "Shorty."

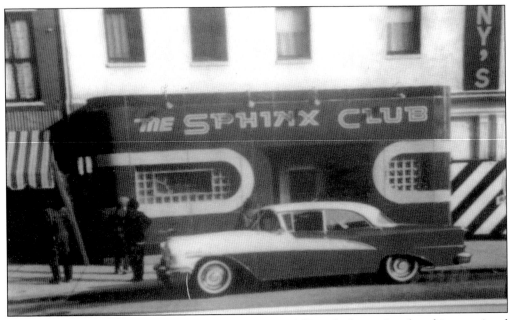

This is the Sphinx Club on Pennsylvania Avenue in 1949. It had a national and international reputation as a place for good food, good music, and good times. (Courtesy of The Henderson Collection, Peale Museum, Baltimore City.)

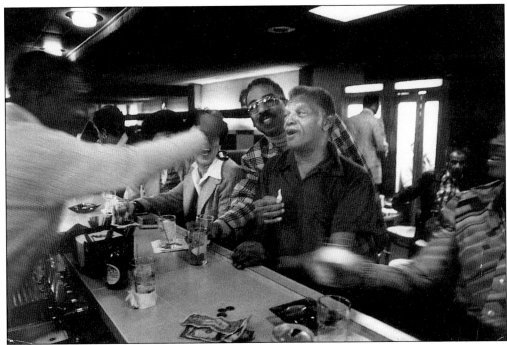

Owner Charlie Tilghman (center) of the Sphinx Club has a laugh with member "Mooche" Johnson, a transplanted Atlantic City fireman.

"It's Madison Time" at the Sphinx with well-known dancers Monterey Kenny and Drury Baskerville.

In this photo of Sphinx patrons, Ophra Lampkins is at far right. She served drinks at the club for over 20 years.

Members of the Sphinx Club sing for the patrons.

Pictured here at the Sphinx are
Bill Hatcher, Orpha Lampkins, and
"The Veep.".

Four
THE FLAME OF FAME

Baltimore's Pennsylvania Avenue, often referred to as "The Avenue," was one of the most popular places for African-American musicians to showcase the richness of their culture. An acceptance and endorsement by "The Avenue" patrons guaranteed a musician's national acceptance and success. From "The Avenue" sprang some of the nation's biggest African-American music artists.

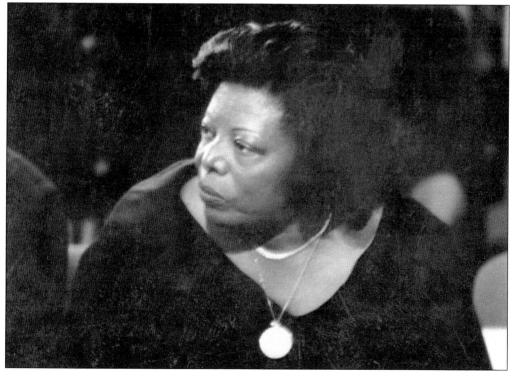

Mary Lou Williams (1910–1981), the "first lady of jazz," is seen in 1972. Born in Atlanta, Georgia, Mary excelled on the keys. By the time she was 16, she led her own jazz band. A gifted composer and arranger, she was hired to write arrangements for bandleaders such as Louis Armstrong, Tommy Dorsey, Duke Ellington, and Benny Goodman. Her style of playing reflected the whole history of jazz. She died of cancer in 1981. (Courtesy of Milt Hinton and David G. Berger.)

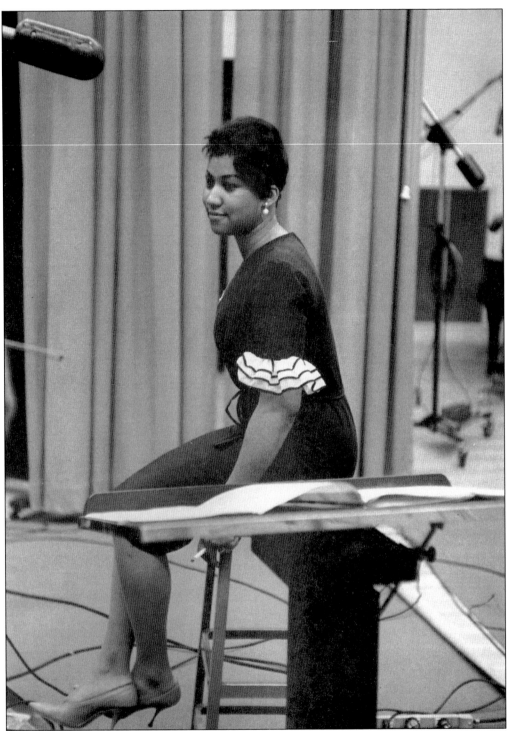

This is a picture of the famous Aretha Franklin. In her younger days, the "Queen of Soul" was seen in concert at the Civic Center, now the Mariner Arena on Charles Street in Baltimore. (Courtesy of Milt Hinton and David G. Berger.)

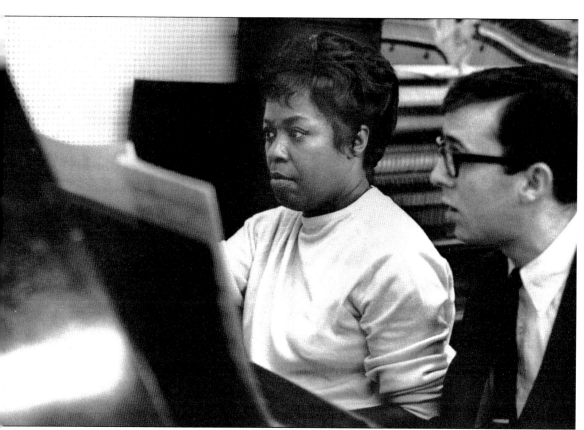

Pictured here is Sarah Vaughn, "The Divine One" (1924–1990). When she was 18, Sarah entered an amateur talent contest at the famous Apollo Theater in New York City. Two weeks later the famous jazz pianist Earl "Fatha" Hines hired her—that was the start of her professional singing career. They called her "Sassy" because her singing style and performing skills were so unique. She recorded both jazz and popular songs. Sarah listened to horn players more than singers to develop her style of scatting. She performed in the Royal Theater and the Sphinx Club. (Courtesy of Milt Hinton and David G. Berger.)

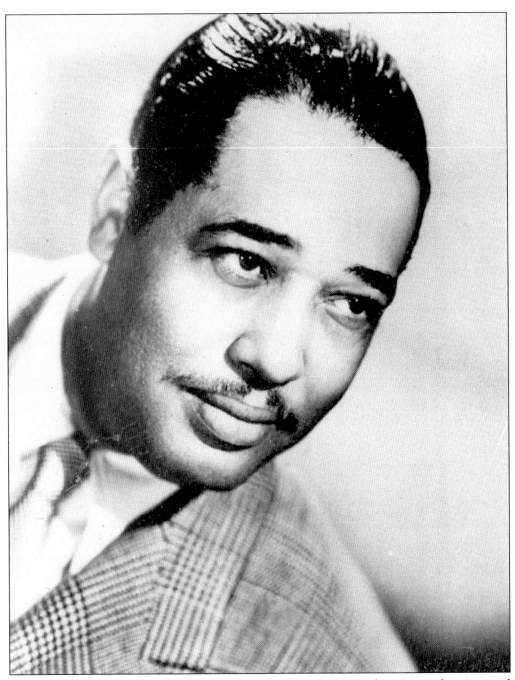

Born in Washington, D.C. on April 29, 1899, Duke Ellington grew up listening to the piano and at age seven he began lessons. He was one of the first jazz musicians to take advantage of the phonograph and was responsible for the first use of the word "swing" to mean a form of jazz. Ellington recorded a song called "It Don't Mean a Thing If It Ain't Got That Swing." It turned out to be a big hit and it represented a milestone of his musical career. The Duke Ellington Band was a favorite at the Royal Theater with Al Hibbler and Ivy Anderson doing the vocals. Ellington died in 1974.

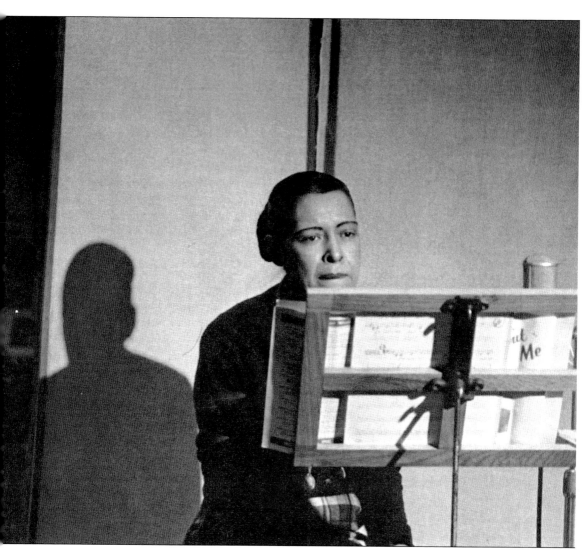

Billie Holiday was born in Baltimore in 1915 and was given the name Eleanor Fagan at birth. Though her personal life was in some ways a song of the blues, her musical contributions shined. In the 1930s she became known as "Lady Day" and gained international fame for her earthly blues style. Her career declined after a narcotics arrest in 1947. At age 44, she died under arrest in a New York Hospital. (Courtesy of Milt Hinton and David G. Berger.)

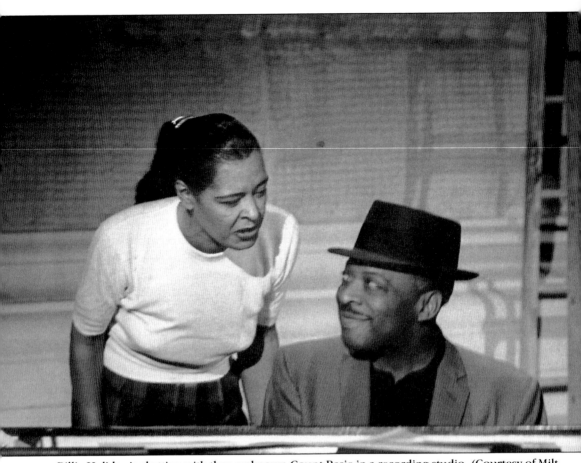

Billie Holiday is chatting with then-unknown Count Basie in a recording studio. (Courtesy of Milt Hinton and David G. Berger.)

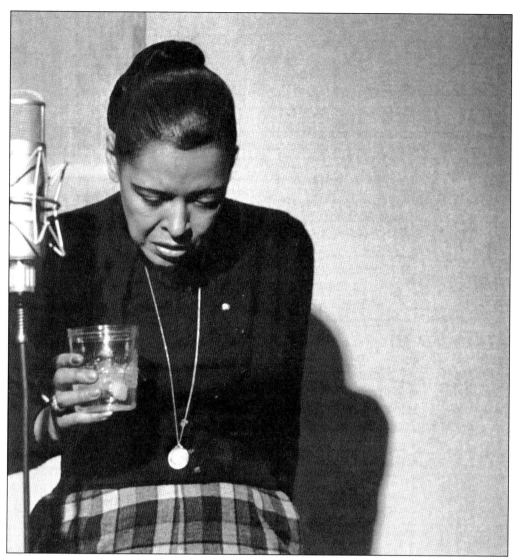

Another view shows Billie Holiday at a rehearsal. Fans called her "The Pride of Baltimore." (Courtesy of Milt Hinton and David G. Berger.)

Born in East Baltimore, Chick Webb was *the* orchestra leader of his time. By 1934, his group was playing at the Savoy in New York. He rescued Ella Fitzgerald from the stifling nest of an orphanage and lifted her songbird wings into flight. Together they soared into success all over the globe. He became known as the "King of Drums," and, of course, we know Ella can break glass with "A Tisket, A Tasket." Ella Fitzgerald held the reigns of the orchestra after Chick Webb's death in June 1939.

Ella Fitzgerald was born in 1918 in Newport News, Virginia. At age 15, Ella entered an Amateur Contest at New York's Apollo Theater. Chick Webb took her home from there and hired her in 1938. Ella composed her most famous song with Chick Webb, "A Tisket A Tasket." Ella recorded more than 2,000 songs and has more than 70 albums to her credit. She has sold over 25 million recordings and has performed with more than 40 symphony orchestras.

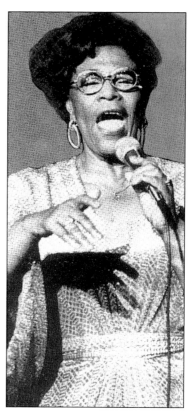

Dinah Washington is seen with, from left to right, Gerry Sanfino, Hank Freeman, and Fred Norman in 1963. Washington, an *Amateur Hour* winner, was from 1934 to 1946 a featured vocalist with Lionel Hampton. She sang and recorded jazz, blues, pop, and some country. Known for being an arrogant hell-raiser, she insisted on being called "The Queen." This talented singer had at least eight husbands. Scandalous newspaper headlines of the 1950s included the following: "Blues Singer Escapes Death by Gift of Glass Candy;" "Gun Rap Deepens Singer's Blues;" "Dinah Washington will be tried for 3rd Degree Assault;" and "Changed Dinah Washington Walks Out on Concert in Winston-Salem Arena." Her life ended with an overdose in 1963, at the peak of her career. She was a favorite in Baltimore at the Royal Theater. (Courtesy of Milt Hinton and David G. Berger.)

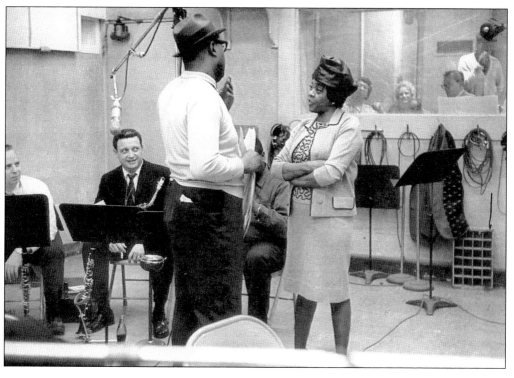

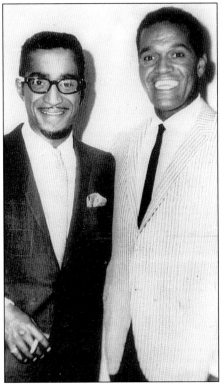

Jackie "Moms" Mabley, seen here with Melvin Edward "Slappy" White, began performing in 1913 at age 16. Born in Brevard, North Carolina, she changed her name from Loretta Mary Aiken to Jackie Mabley. A spicy, raucous comedian, she toured the country for 50 years, hitting legendary black theatres such as the Regal, Royal, and Monogram in Chicago, and the Apollo in New York, where she became the undisputed queen of comedy. Moms's early monologues were written by comedian Bonnie Drew Bell and herself. Moms would amble onto the stage, wearing tattered "Raggedy Ann" dresses, oversized shoes, drooping argyle socks, and a floppy hat. She would smile broadly to show she didn't have any teeth. Moms starred in the movie *Amazing Grace,* along with "Slappy" White. He was born September 27, 1921, in Baltimore near the Royal Theater, where he was a candy boy. At the age of 14, he left school, hopped a freight train and played night clubs on "The Chittlin' Circuit." He and Redd Foxx got together in Baltimore and became a comedy team in 1940. Slappy was married twice to world-famous entertainers—Pearl Bailey and Laverne Baker. At left he is pictured with Sammy Davis Jr. Slappy had no children. He died November 7, 1995.

Redd Foxx, trailblazing comedian and actor, claimed Baltimore as his second home.

Pearl Bailey got an early start in entertainment as a chorus girl at the Royal Theater during the late 1930s and early 1940s. Pearl worked extensively with Count Basie throughout 1948.

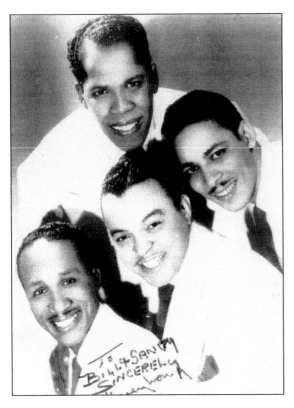

Arguably the first R&B male vocal group to enjoy international recording success, the Ink Spots started in Indianapolis, Indiana in 1932 as the Riff Brothers and later as the Percolating Puppies. Members included Ivory "Deek" Watson, Orville "Hoppy" Jones, Charles Fuqua, and Jerry Daniels. Around 1936 the group met West Baltimore native Bill Kenny on a trip to New York. Kenny replaced Daniels as lead crooner and in 1939 they had their first hit and most famous recording "If I Didn't Care," an R&B standard. Other hits include "I Don't Want to Set the World on Fire," Whispering Grass," and "My Prayer." Since the Ink Spots, every male R&B vocal group has patterned their vocal choreography after the Ink Spots, with Kenny's often-imitated high tenor and Hoppy's talking bass. Clockwise from top is a 1945 version of the Ink Spots, Bill Kenny, Herb Kenny (Bill's brother), Billy Bowen, and Huey Long. (Courtesy of Bill Proctor.)

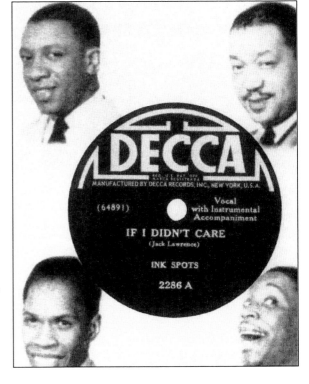

This is a Decca label promotional photo. The Ink Spots had most of their hits on the Decca label. From top left clockwise are Charles Fuqua, Orville "Hoppy" Jones, Ivory "Deek" Watson, and native Baltimorean Bill Kenny. (Courtesy of Bill Proctor.)

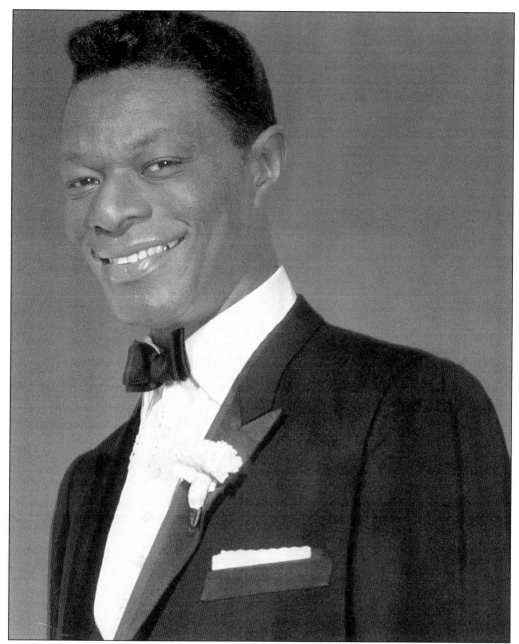

Nat King Cole played the piano from the age of 4. At age 5 years old he played the church organ and piano in his father's church. Nat King Cole changed the face and sound of jazz and R&B with his smooth style and charming good looks. In 1946, he played at the Club Charles in Baltimore.

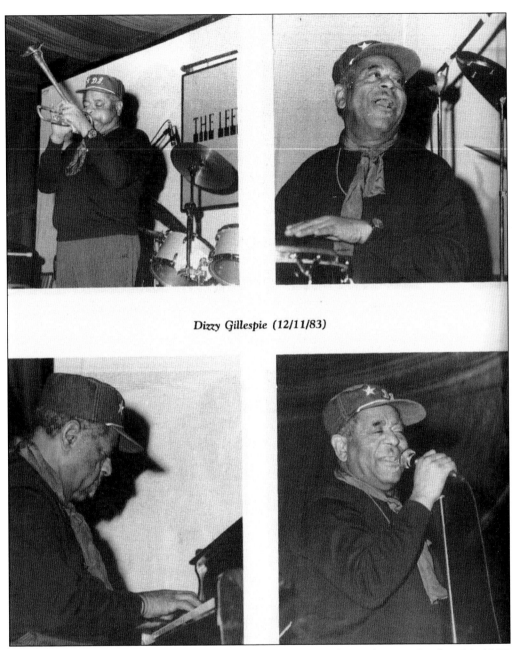

Dizzy Gillespie (12/11/83)

Dizzy Gillespie was born John Birks Gillespie in Cheraw, South Carolina on October 21, 1917. Dizzy earned the title the "King of Bop." The outstanding trumpet player appeared at the Comedy Club in Baltimore. He is seen here at Baltimore's Left Bank Jazz Society.

Lena Horne was born June 30, 1917 in Brooklyn, New York. Show business came early for her. In 1933, at age 16, she became a chorus girl at the Cotton Club. Cab Calloway was playing there at the time before an all-white clientele. Lena quickly became a featured singer with Cab. Lena's Hollywood career was curtailed by her refusal to play "mammy" roles, which were demeaning to blacks. She stood her ground and paid the price—she was blacklisted for her left-wing associations during the McCarthy era. However, Lena Horne was still the nation's top black entertainer. She last appeared in Baltimore in the 1960s at the Morris Mechanic Theater.

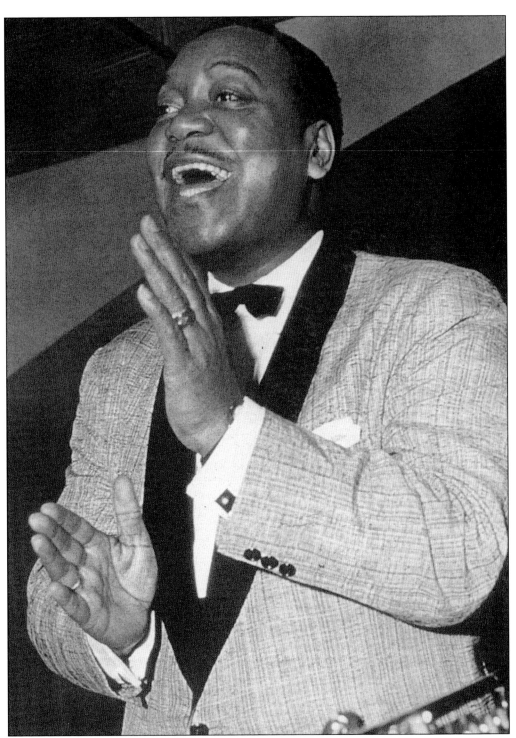

None other than the incomparable Cab Calloway nurtured this gentleman trumpeter with his irrepressible, perky style. Jonah Jones had his trumpet and vocals tuned to the times, creating his distinctive brand of swinging happiness. Jonah appeared with the Calloway Band in Baltimore.

Five

THE LOCAL CHITTLIN' CIRCUIT

There was a time when a musician's success was not brought on by commercial exploration. Musicians earned every ounce of their success, crossing many toll bridges to pay their dues. A sincere love for their art mixed with their deeply rooted commitment to their culture gave these musicians the courage, discipline, and strength to weather the stormy seas of life's struggles and perils. They gave their hearts and souls to their music and survived on the appreciation given by their audiences. This chapter features local artists. These dedicated musicians sometimes make barely enough money to meet their immediate needs; nevertheless their musical passions continue to sustain them in ways that money never could.

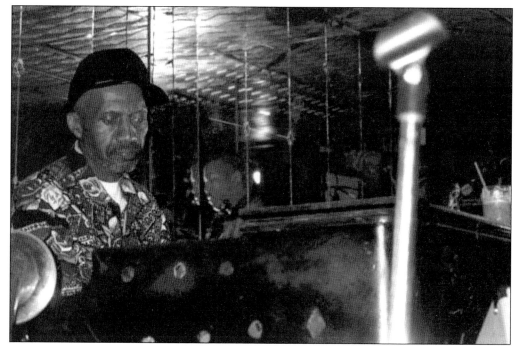

This is Alvin Hamlinton, a well-known local organist, songwriter, and producer.

Dottie Tims, a local organist, has performed all over the world.

Brenda Alfred is a jazz vocalist from Baltimore.

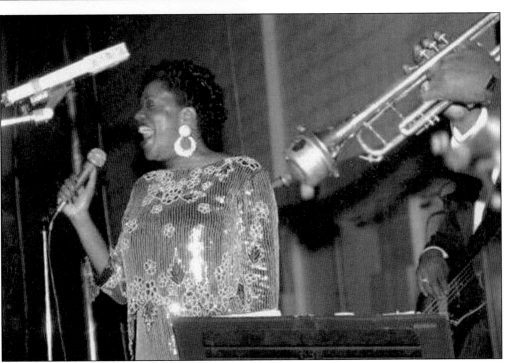

Dave Smith can play all wind instruments, sing, and is a recording artist. He has played with many international greats.

Seen here is Bobby Ward, a very popular and gifted drummer, singer, and entertainer.

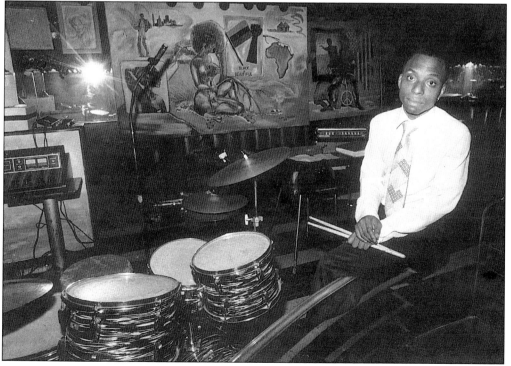

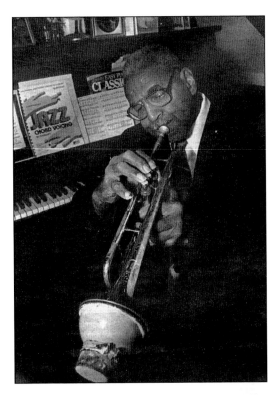

The late Roy "Tanglefoot" McCoy, trumpeter and former member of the Royal Men of Rhythm (the house band of the Royal Theater), has played for Billie Holiday, Cab Calloway, Flip Wilson, the Drifters, the Coasters, Moms Mabley, and Harry Belafonte, just to name a few. (Courtesy of Benjamin Pope.)

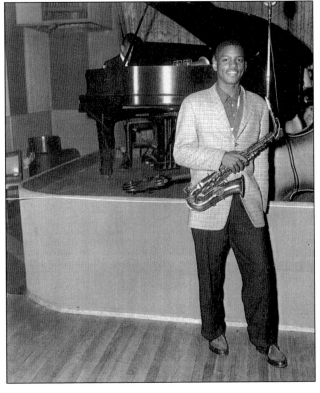

Carlos Johnson is seen here playing at the Comedy Club on Pennsylvania Avenue at age 17. This was his first professional gig. Carlos and his Zone One band are among the most popular Baltimore groups. For 15 years, Carlos traveled with singer Damita Jo. (Courtesy of Carlos Johnson.)

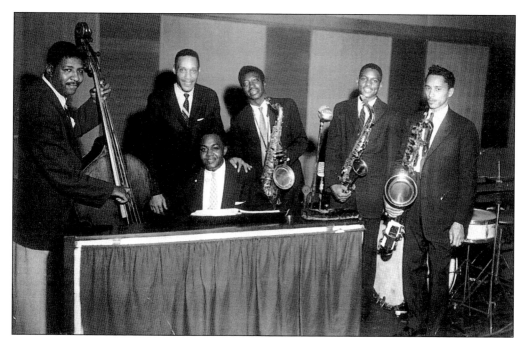

These local musicians who made names for themselves are, from left to right, the late Elwood Adams on upright bass, the late Tam Williams on drums, Joe Adams on piano, Wilbert Stewart on tenor sax, Carlos Johnson on alto sax, and the late Edward Tobias on baritone sax. They called themselves "the Tune Makers." They were the house band for the Comedy Club in 1957.

Artist and photographer Robert O. Torrence is seen hard at work in his studio in 1983. He took all of the Sphinx Club pictures in this book. (Courtesy of Dawn Magazine.)

Pictured here is the legendary Count Basie.

The famous R&B singer Dee Clark leads the band in song and well-known Baltimore organist Cornell Muldrow is seen on the organ. The late Cornell Muldrow was leader of his own group— The Bim Bam Boom Trio, which served as the house band at the Lucky Number Club on Poplar Grove Street in West Baltimore.

The late Damita Jo, a jazz great, was born in Austin, Texas, but found warmth and comfort in the Baltimore music scene. She enjoyed international success in South America, Japan, Sweden, and Norway. One of her first recordings, "Love is A Ball," a duet with Billy Eckstine, was a huge hit in Australia. "I'm Saving the Dance for You" sold one million copies. She recorded the first English version of "Yellow Days." "The Color of Your Skin Makes No Difference" was written and recorded by Damita Jo and was played in schools and churches all over Baltimore. In 1977, she toured with the Redd Foxx Revue. She was married until her death to the journalist and promoter James E. "Biddy" Wood Sr. (Courtesy of Carlos Johnson Collections.)

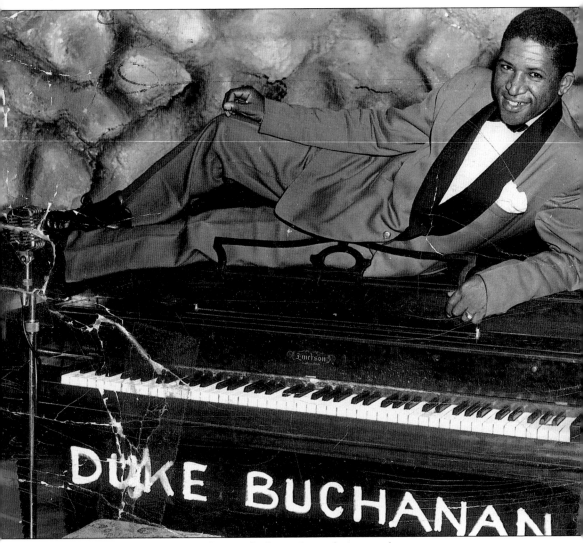

The late Duke Buchanan was known for his unique playing on the organ.

Ellis Larkins is seen here in 1962. Born in Baltimore in 1923 to parents who were classical musicians, Ellis became the first black student admitted to Baltimore's prestigious Peabody Conservatory of Music. An extraordinary pianist, Ellis had a long and successful career as a recording artist and teacher, recording with such greats as Ella Fitzgerald. He died in 2002.

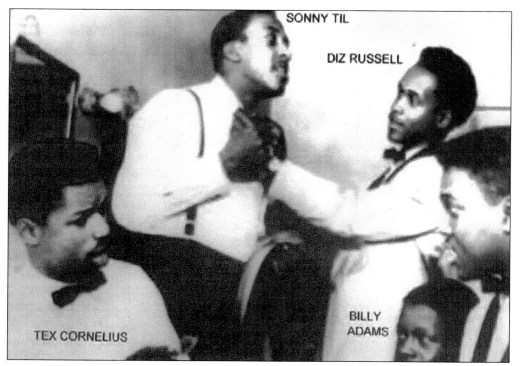

Earlington C. Tilghman, affectionately known as "Sonny Til," was born in Baltimore. He was the founder and lead singer of The Orioles. The first song The Orioles recorded was "It's Too Soon to Know" on Jubilee Records. Other hits were "Tell Me So," "Forgive and Forget," "At Night," "Chapel in the Moonlight," "Crying in the Chapel," and "What Are You Doing New Year's Eve?"

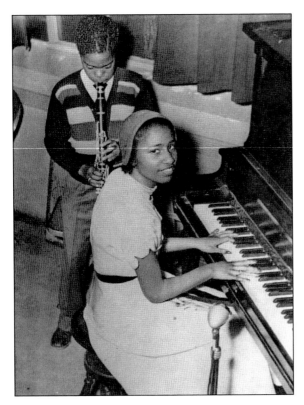

Andrew and sister Ethel Ennis, born and raised in Baltimore by a music teacher mother Mrs. Arable Sarah Ennis, are shown here performing a duet. Ethel and Andy began singing and playing in church at Amos United Methodist Church, where their mother also played piano. Mrs. Ennis taught her children to play piano and read music. Ethel could barely tolerate Andy's beginning squawks on the "licorice stick" at the beginning of their career in 1950. (Courtesy of Ethel and Earl Arnett.)

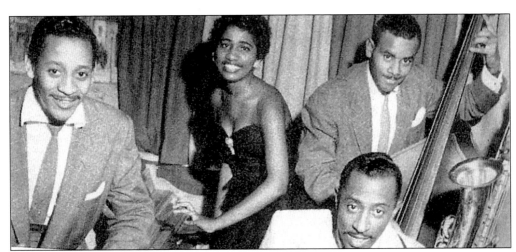

A graduate of Douglas High School, an African-American high school in Baltimore known for its music program, Ethel was working with a very well-known band called The Tilters by the early 1950s. One of the guys who acted as Ethel's protector during the rough and raw years was the band's bassist, Arthur Nelson. After The Tilters disbanded, Ethel played and sang with the JoJo Jones Ensemble pictured here. The bass player was Montell Poulson. He and Ethel later formed a musical duo. (Courtesy of Clinton's Studio.)

RED FOX LOUNGE

1st and Last Stop On The Avenue

Proudly Presents

SOMETHING NEW AND INTIMATE IN THE LINE OF
ENTERTAINMENT

7—NIGHTS WEEKLY—7

Featuring

**ETHEL
ENNIS
ON THE
KEYS**

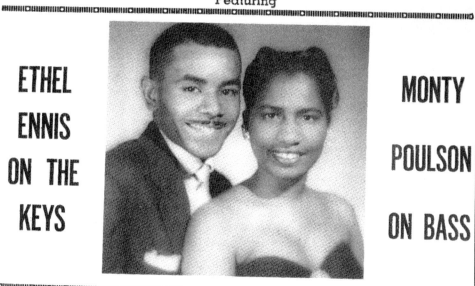

**MONTY

POULSON

ON BASS**

They will win you over with their wonderful repertoire of new and
captivating songs

So Guys Bring Your Queens
and
Girls Bring Your Kings

and be enraptured by their refreshing personalities

Our kitchen is open until 1:30 A. M. for the finest food—from a sandwich
to a meal—under supervision of Bobby Cooper, formerly of the Tijuana

SPECIAL AT ALL HOURS—CHICKEN IN A BASKET

PACKAGE GOODS STORE—OPEN SUNDAY

SHOW TIME—9 UNTIL SUN. MATINEE—7 UNTIL

RED FOX LOUNGE
"First and Last Stop on the Avenue"
COR. FULTON & PENNSYLVANIA AVES.

This billboard shows Ethel Ennis and Monty Poulson at the Red Fox Lounge on Pennsylvania
Avenue. George and Reba Fox, proprietors of this hopping local establishment, discovered Ethel
and hosted her at the Red Fox in 1954. The club was one of the few integrated spots in the city
during that era. The Red Fox became Ethel's home base for nearly a decade.

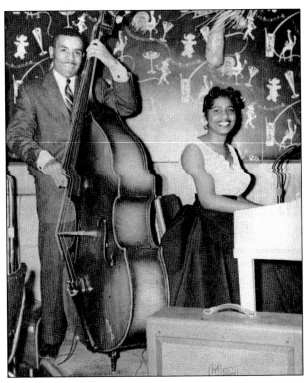

Ethel and Monty Poulson
are pictured at the Red Fox
on Fremont Avenue and
Reisterstown Road.

A group of local musicians get
together to jam in a local club.
From left to right are Gary Grainger,
Earl O'Maro, Mickey Fields, Eddie
Gough, Johnny Polite, and Rick
Johnson. (Courtesy of Rosa Pryor.)

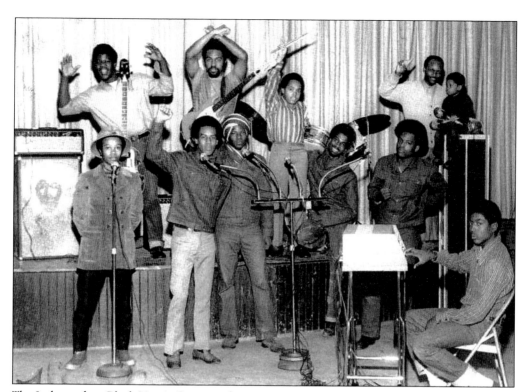

The Independent Black Men in Song, or the "IBMs," was another local group that enjoyed much local success. The group practiced each day after school. Members included Baltimore natives (from left to right down front) Charles Sims, Roland Campbell, Wayne Jones, Raynard Chance, and Tim Capers. Steven Jones is on the keyboards and Johnny Creadle is on guitar. Known for their acrobatic prowess and dynamic dance moves, the group was one of the first live acts to perform at the Mondawin Mall in West Baltimore in 1978. Dennis Chambers, or "DC," who has played the drums since the age of four, is pictured here at age 10 raising his drumsticks with the peace sign. Chambers is currently one of the most popular and sought-after drummers in the world. One of his most famous gigs was his tenure with Parliament-Funkadelic. He has played with David Sanborn, Mike Stern, and George Duke as well. His session work as a percussionist is phenomenal; Baltimore is pleased to call him her own. (Courtesy of Rolan Campbell.)

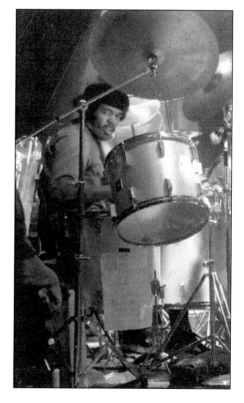

Here is Dennis Chambers (right) all grown up, co-piloting the Parliament Funkadelic Mothership in the late 1970s.

Seen here are Jackie Lanier, a renowned historian, and Bill Harvey, radio personality.

This is the late Jennell Fisher, song stylist.

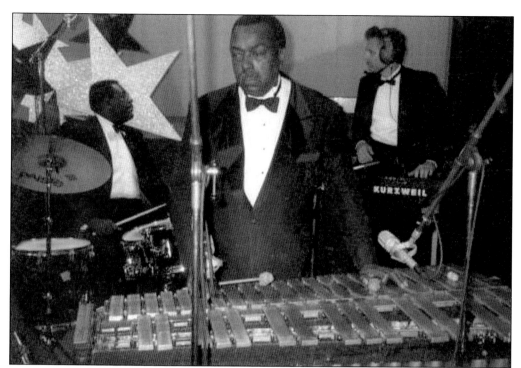

Pictured above is Jimmy Wells, pianist and vibraphonist, who was a fixture at the Left Bank Jazz Society concerts of the 1960s.

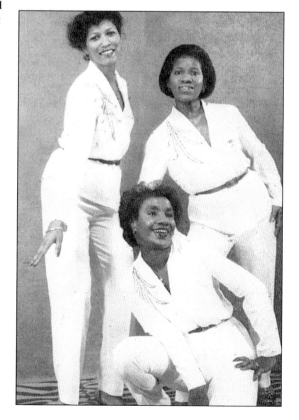

Diane and the Ravenettes, a four-girl R&B group born and raised in Baltimore, were (standing left to right) Diane Williams, and Pamela Ferguson, and (kneeling) Carolyn Diggs. Bernadine Harrison is not shown. A local R&B (now gospel) promoter named Lonnie Parker discovered these girls and made them famous in the Baltimore area. (Courtesy of Rosa Pryor.)

Shown here is Jody Myers. Now residing in Los Angeles, she was a regular at the Bird Cage.

Seen to the right is Judd Watkins, premier vocalist.

Baby Lawrence was Baltimore's premier hoofer and danced all over the world.

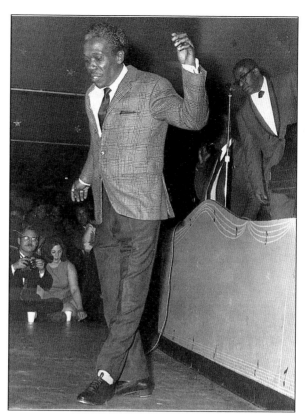

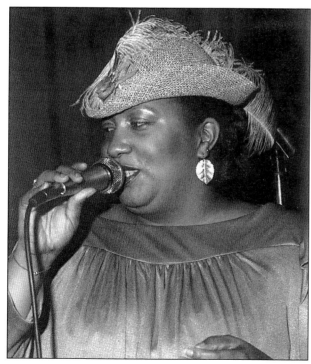

"Lady Rebecca" Anderson was a popular local vocalist.

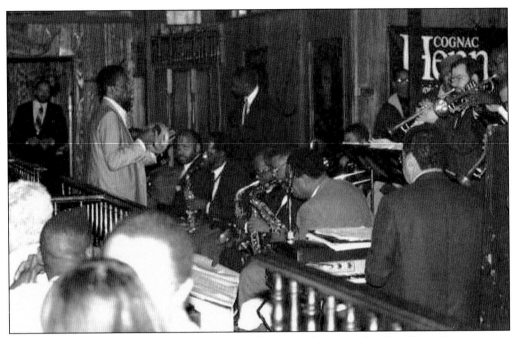

The late Lewis Hamlin is shown here with his 16-piece orchestra at the New Haven Lounge, one of the last places he performed before he died. Born in Macon, Georgia, Lewis Hamlin enjoyed professional success as the chief music arranger for *The James Brown Show*. He began his term with James Brown and Famous Flames in 1961. He completed his master's degree at Towson State University in Towson, Maryland, and taught music education in the Baltimore City public school system, including Carver, Forest Park, Southwestern, and Dunbar High Schools. Hamlin established instrumental music programs in other schools as well. His greatest achievement is the formation of his own 16-piece orchestra that performed all over the country.

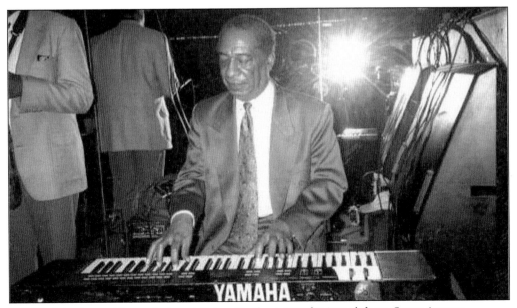

Phil Clark is pictured here playing at Caton Castle, a popular jazz club on Caton Avenue.

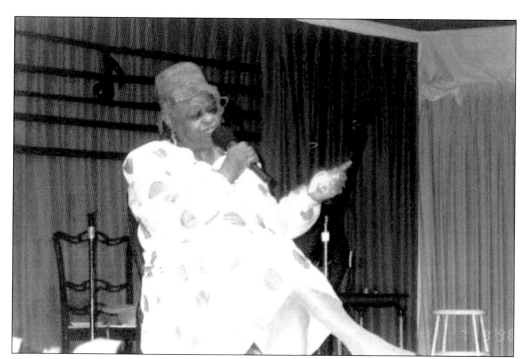

This is Mable Aquilla Larkins, comedian, actress, and model, Baltimore's own "Moms Mable."

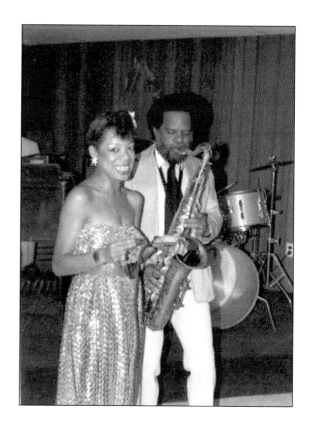

The late Nikki "Super Duper" Cooper is seen with Andy Ennis.

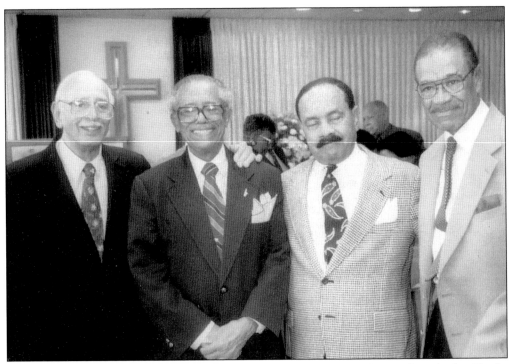

The following are some of the true legacies of Baltimore: (from left to right) Charles Harris, Tracey McCleary (former band leader of Baltimore's famous Royal Theater house band), Monty Poulson, and Melvin Spears.

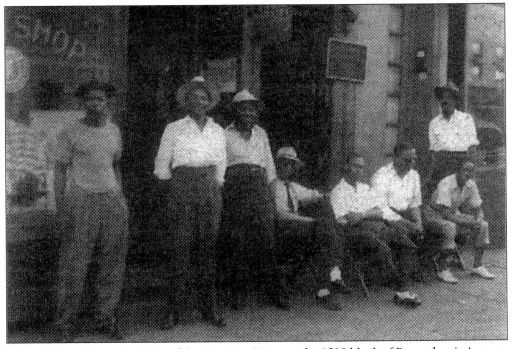

Musicians are gathered outside of the Musician Union at the 1500 block of Pennsylvania Avenue.

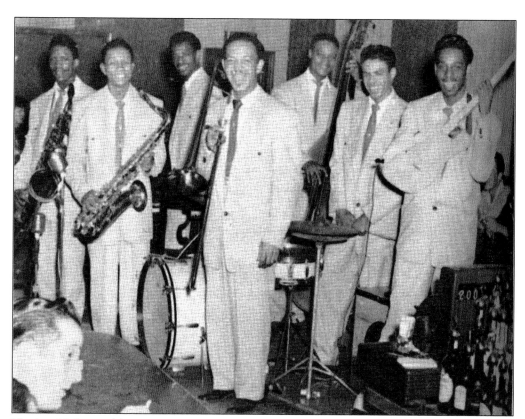

The late Mickey Fields, a saxophonist and completely self-taught musician, was one of seven children, who were all musicians. He began playing at five years of age. His brother brought him a saxophone upon his return from World War II and Mickey fell in love with the instrument. Mickey and his sister Shirley, a pure jazz singer, decided to form their own musical ensemble with five friends in the early 1950s. They called themselves "The Seven Tilters." Here we see Mickey (second from the left) on the stage with his fellow band members. He was truly gifted as a pianist, drummer, bassist, trombonist, flutist, and guitarist—but his claim to fame was the saxophone.

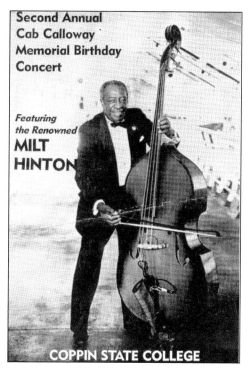

Second Annual Cab Calloway Memorial Birthday Concert

Featuring the Renowned MILT HINTON

COPPIN STATE COLLEGE

Seen here is the late great Milton Hinton, known as "The Judge," who was featured at the second annual Cab Calloway Memorial Birthday Concert at Coppin State College. Hinton was born in Vicksburg, Mississippi, and raised in Chicago. he enjoyed a long and successful career as a recording artist.

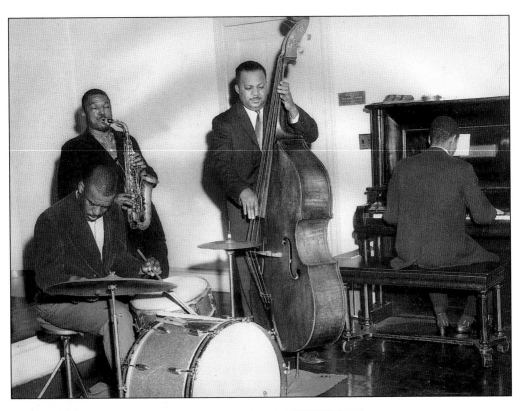

Here are Phil Harris, Benny McQuire, and Wardell Young, and an unidentified gentleman on keyboard.

Ralph Fisher, drummer, is pictured here. He's still swinging!

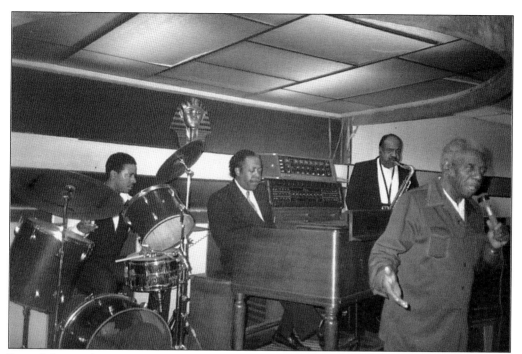

From left to right are "Face" on drums, Sir Thomas Hurley on organ, Eddie Gough on sax, and Earl O'maro on mic.

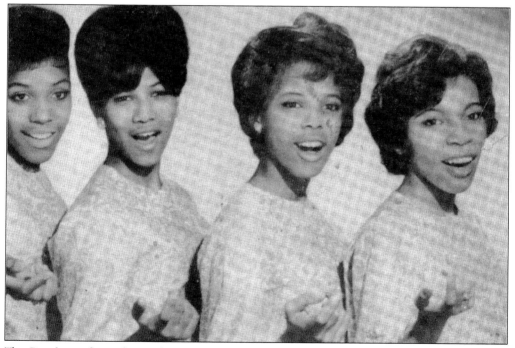

The Royalettes formed in Baltimore in the early 1960s and included Sheila Ross, Anita Ross, Ronnie Brown, and Terry Flippen. Their third release on MGM records, "Gonna Take a Miracle," made it to number 41 on the Billboard charts.

Ruby Glover, renowned jazz song stylist, is called "The Godmother of Jazz" by the people of Baltimore. She is a native of the city and has been performing professionally since 1967. From 1964 to 1966 she played the Playboy Nightclub Network. She has shared the stage with top artists such as Art Blakey, Sonny Stitt, Keter Betts, Doug Khan, and Charles Covington, and local sister vocalists such as Ethel Ennis, Brenda Alfred, and "Lady Rebecca" Anderson. Her mother inspired her to pursue her musical career. Ruby is a music educator at the Sojourner Douglas College in East Baltimore, home of the Left Bank Jazz Society Archives. (Courtesy of Ruby Glover.)

This is a picture of Mack Rucks, renowned trumpeter, teacher, and bandleader. (Courtesy of Eugene Daniel.)

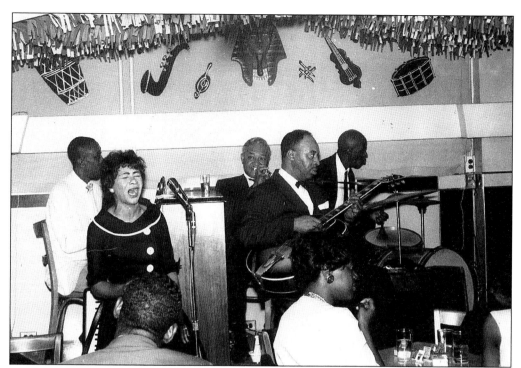

Pictured here is Shirley Fields, Mickey Fields's singing sister, and the Sphinx Club Band.

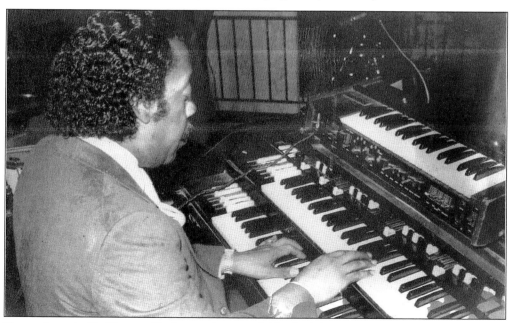

Shown here is Sir Thomas Hurley, as he was dubbed while touring in Europe with the late renowned jazz songstress Damita Jo. The title is aptly bestowed on this outstanding pianist and organist. Born and raised in Baltimore, Sir Thomas has that inimitable styling and sensitivity and his audiences easily become attuned to his "vibes." A talented man, he is dedicated to his art and generously shares his precious gift.

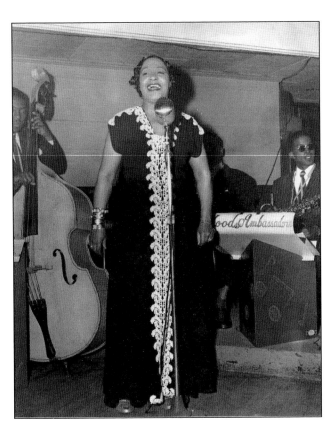

An unidentified vocalist performs at the Sphinx Club.

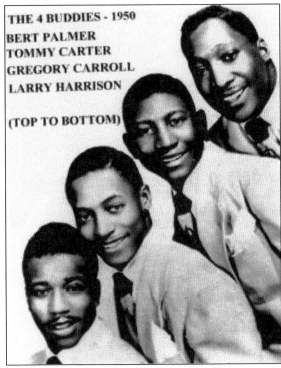

THE 4 BUDDIES - 1950
BERT PALMER
TOMMY CARTER
GREGORY CARROLL
LARRY HARRISON

(TOP TO BOTTOM)

The Four Buddies are pictured in 1950. The group started as the Metronomes, and members included Bert Palmer, Tommy Carter, Gregory Carroll, and Larry Harrison. Their vocal power landed them a gig on WITH-FM radio every Saturday for 15 minutes. Later, Herman Lubinsky chose the group to sing backup for his Savoy record label's hottest act, The Johnny Otis Show. Shortly thereafter Lubinsky was signed to the quartet. They were the only Savoy Records recording artists to have a top-ten hit, which was "I Will Wait" in 1951. (Courtesy of Marv Goldberg, *R&B Notebooks*.)

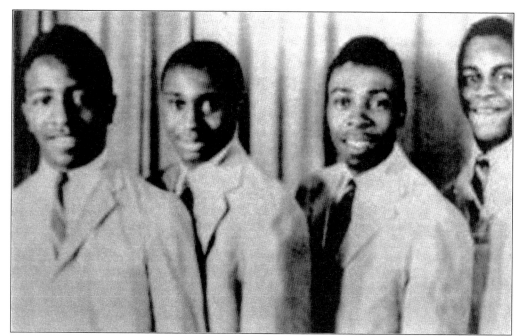

The Plants were a young group of neighborhood friends who grew up in Baltimore on Schroeder Street. From left to right, George Jackson (lead), Steve McDowell (first tenor), James Lawson (baritone), and Thurmon Thrower were the group's four members. After harmonizing backstage at the Royal Theater during a concert featuring Johnnie & Joe (J&S Records's number-one act at the time), the group was signed by label owner Zell Sanders almost immediately. They enjoyed a splash of local success with "Dear I Swear" and "It's You," both recorded on J&S Records. This photograph was taken c. 1957. (Courtesy of Marv Goldberg, *R&B Notebooks*.)

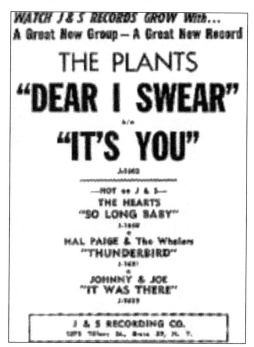

This is The Plants promotional billboard for "Dear I Swear" and "It's You." (Courtesy of Marv Goldberg, *R&B Notebooks*.)

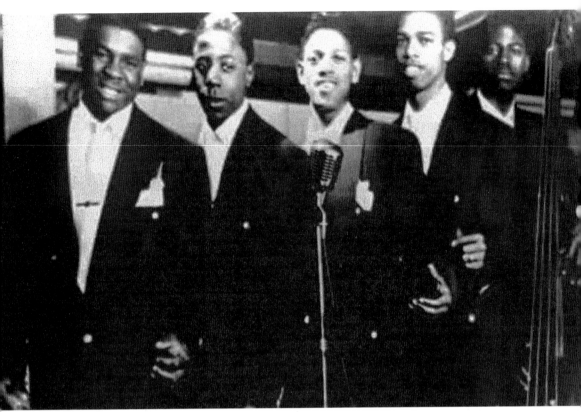

"The Swallows," an R&B vocal group from Baltimore, was comprised of Eddie Rich (lead), Irving Turner (tenor/baritone), Earl Hurley (tenor), Herman "Junior" Denby (second tenor/baritone), Frederick "Money Guitar" Johnson (baritone), and Norris "Bunky" Mack (bass). After a record company executive unintentionally overheard the gentlemen practicing at the Royal Theater, the ensemble signed a record contract with King Records. The Swallows enjoyed success through the 1950s and their biggest hit, "Beside You," is still an R&B classic. Shown here is the 1951 quintet, which included, from left to right, Earl Hurley, Fredrick "Money Guitar" Johnson, Eddie Rich, Norris "Bunky" Mack, and Herman "Junior" Denby. (Marv Goldberg, *R&B Notebooks*.)

Timothy "Tiny Tim" Harris, renowned local baritone vocalist, has recorded many records still performed in major Balitmore clubs.

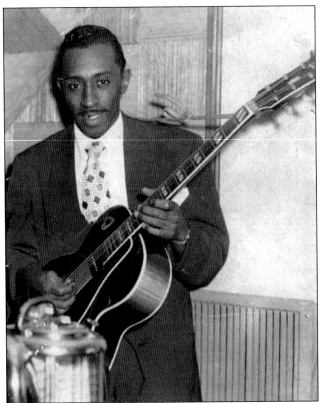

Native Baltimorean Joseph "Jo Jo" Jones (co-author Taliaferro's great uncle) mastered all instruments, with an eighth-grade education, during the 1930s, 1940s, and 1950s. He played in the bugle corp during his stint in the Army, and upon his release he began to make a name for himself as a bandleader of the Jo Jo Jones Ensemble. His popularity as a musician, however, paled in comparison to his reputation as an extraordinary hoofer. The demand for his instrumental skills equaled the demand for his dancing prowess. He is pictured here with his favorite guitar in an Avenue nightclub during the 1940s. He was also a visual artist and some of his sculptures and paintings are housed at the Baltimore Museum of Art. (Courtesy of Rosalie Stewart.)

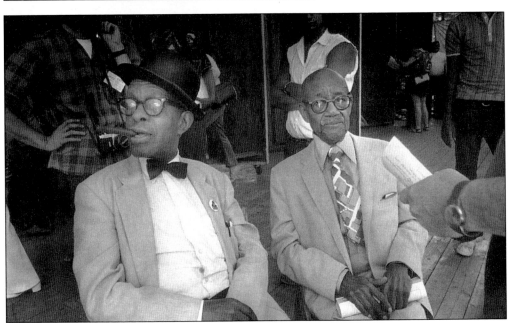

Pictured here are Willie "the Lion" Smith and Eubie Blake. Baltimorean Blake was best known for his song "I'm Just Wild about Harry," which was used by Harry Truman as a theme on his way to the White House.

David Ross was a master of the piano, violin, and organ. His first love was the Hammond organ. According to one local Baltimorean, the love affair was obvious once one heard him play. He shared the stage with many other local Chittlin' Circuit musicians and comedians Redd Foxx and Dick Gregory. Mr. Ross performed at the 1981 inaugural ball for former President Jimmy Carter.

Alfonso Brown Jr. is a Baltimore transplant from Fairmont, West Virginia. Baltimore has never been the same since Al graced the city with his vocal presence. He is known as the "Madison King" because of his chart-topping success with the tune "The Madison," which he wrote to describe a dance craze of the same name. He and his brothers formed their vocal group, called the Tune Toppers, and toured with Gladys Knight and The Pips, Chubby Checker, Clyde McPhatter, Nina Simone, and Screamin' Jay Hawkins. Baltimoreans have had the privilege of hearing the Tune Toppers at the Adams Cocktail Lounge in Turner Station and North Avenue's Rail Inn.

Six

THE MARQUEES

And where could you go to see and hear these exciting artists? In Baltimore there were quite a few places where the African-American community could paint the town red. The bright lights of the gargantuan marquees enticed spectators into the city's liveliest venues. Of course, the Royal Theater, located at 1326 Pennsylvania Avenue, was the most popular theater in the city. The Regent, even larger than the Royal, was two blocks from the Royal and could accommodate 2,000 starry-eyed patrons. And when summer brought its heat and humidity into the city, the beaches opened their gates to the hottest stars of the era. Thank goodness the water rested at the shore, close by to cool everybody down!

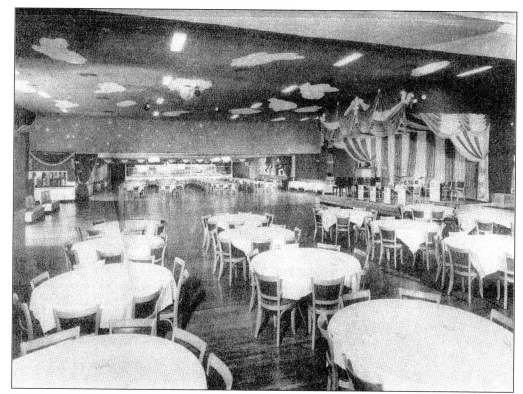

This is the interior of the Famous Ballroom at 1717 North Charles Street, which was the home of the Left Bank Jazz Society, Inc. in the 1970s. (Courtesy of Left Bank Jazz Society Archives.)

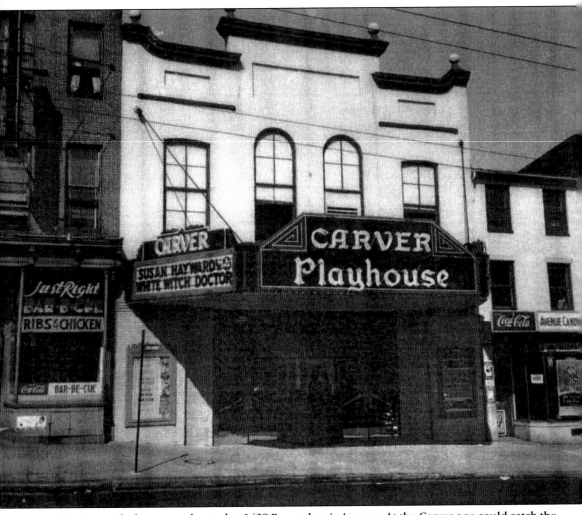

The Carver Playhouse was located at 1429 Pennsylvania Avenue. At the Carver one could catch the latest movie or see a live music show. (Courtesy of The Center for Cultural Education Inc.)

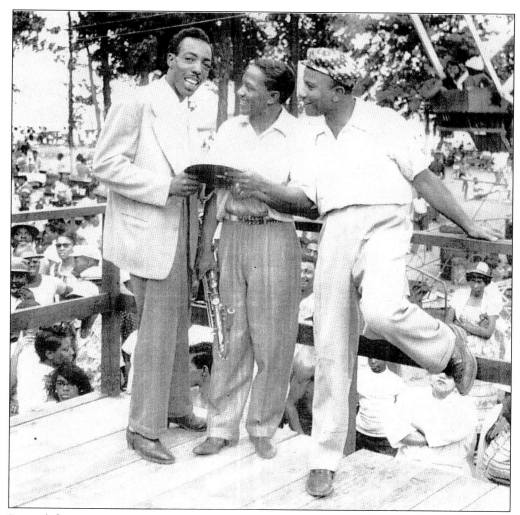

From left to right, Annapolis disc jockey Hoppy Adams, Illinois Jacquet, and a spry Hal Jackson, Hoppy's mentor and radio inspiration, pose at Sparrow's Beach while sharing Illinois's recorded success with an awestruck crowd. Sparrow's, situated next to Carr's Beach, was another venue for people to enjoy live African-American music and good times. (Courtesy of C.W. Adams Jr.)

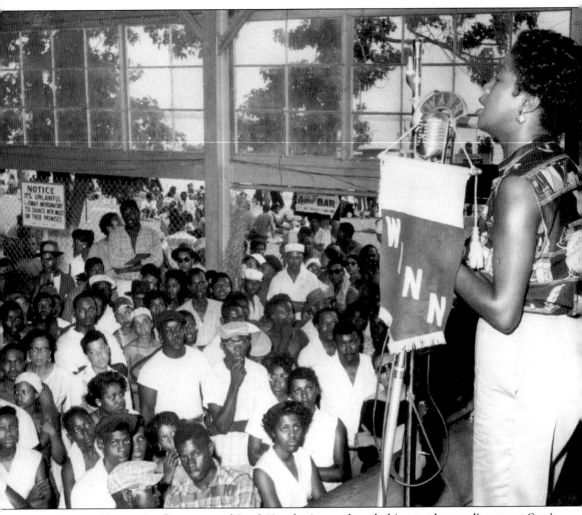

A young blossoming flower named Sarah Vaughn is seen here belting out her soul's song at Carr's Beach. During the 1950s and early 1960s, Carr's Beach in Anne Arundel County was still segregated. Carr's was the most famous of the beaches and was affectionately called "the beach." During the week, it was a place for day camp, church picnics, etc. But on the weekends—especially Sunday afternoons—Carr's Beach had the unique distinction of being a major stop on the "Chittlin' Circuit." On Saturday nights fans would go to the beach and see stars such as Ray Charles, Bill Doggett, Dinah Washington, Author Prysock, and others. Thousands of people from as far away as Philadelphia would come to the beach to swim and picnic. But at three o'clock, it was show time and people would pack into the pavilion to dance and see the major R&B stars of the day. Stars such as Little Richard, James Brown, Lloyd Price, Etta James, the Shirelles, the Coasters, the Drifters—you name 'em, they played Carr's Beach. (Courtesy of Maryland State Archives.)

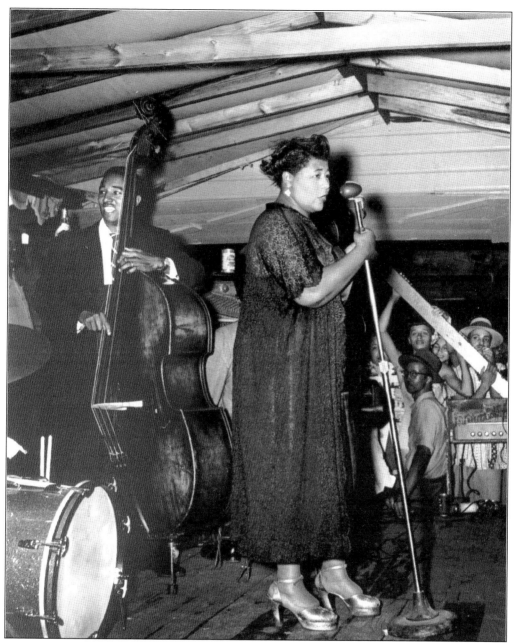

Ella Fitzgerald is pictured here singing on the stage at Carr's Beach in the mid-1950s. (Courtesy of Maryland State Archives.)

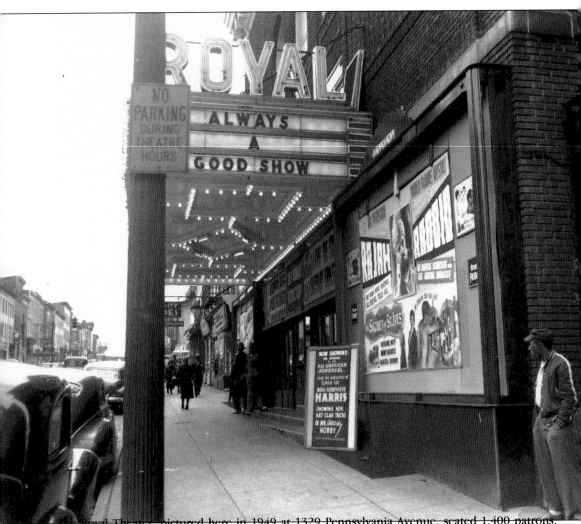

The Royal Theater, pictured here in 1949 at 1329 Pennsylvania Avenue, seated 1,400 patrons. The Royal was built as the Douglas Theater by a group of black entrepreneurs. The theater was bought by a group of white businessmen and the name was changed to the Royal Theater. Fats Waller performed for the theater's first run as the Royal. Thereafter, a famous band was billed every week, along with the country's top African-American singers and comedians. The Royal owed much of its success to segregation because African-American spectators and entertainers were barred from white theaters. African-American performers traveled the "Chittlin' Circuit," a national network of white-owned but black-patronized vaudeville and movie houses that included the Apollo in New York, the Howard in Washington, D.C., the Earl in Philadelphia, the Regal in Chicago, and the Royal in Baltimore. Duke Ellington and Louis Armstrong played exclusively at the Royal when they were in Baltimore. Singers Ella Fitzgerald and Billie Holiday were regulars at the Royal, and Pearl Bailey got her start there as a chorus girl. (Courtesy of Henderson Collection from Peale Museum.)

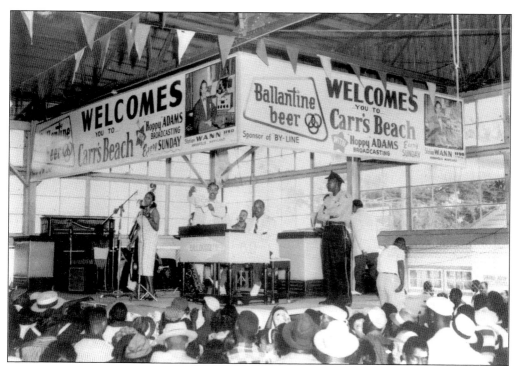

Carr's Beach, right on the edge of Annapolis, Maryland, was home of the concert series "Bandstand on the Beach," hosted by radio personality Hoppy Adams. The beach was operated by Mr. Rufus Mitchell and the show was broadcast live on WANN-AM. This photo shows Hoppy in the middle of the bandstand, reigning over his concert kingdom. (Courtesy of the Maryland State Archives.)

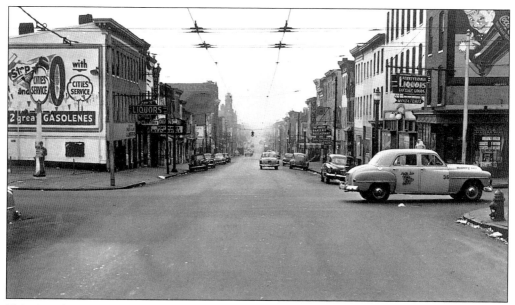

This view shows Pennsylvania Avenue and Mosher Street in the mid-1940s. One block away stood the Royal Theater. (Courtesy of the Henderson Collection.)

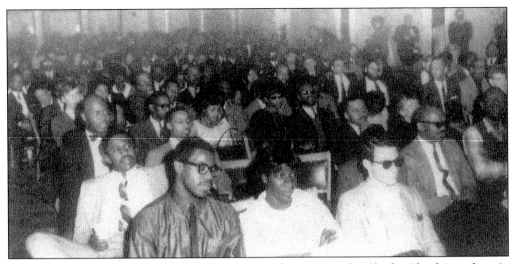

Patrons hanging out at the Crystal Ballroom were there to see the Charles Lloyd jazz show in February 1966.

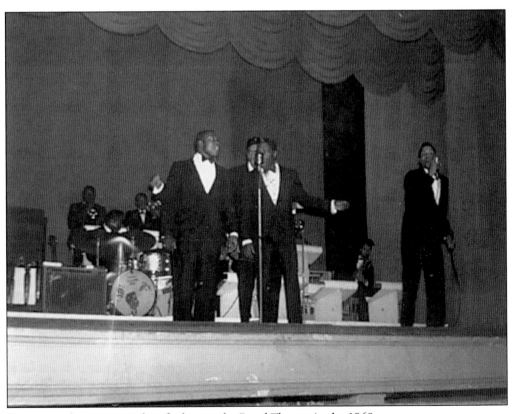

This image depicts an unidentified act at the Royal Theatre in the 1960s.

Here is an unidentified female group, dressed in the style of the day, performing at the Royal Theatre in the 1960s.

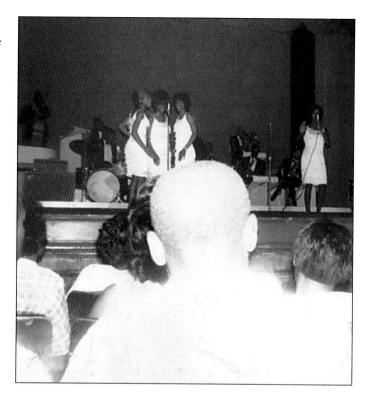

The billboard of the Old Regent Theatre on Pennsylvania Avenue declares that Susan Hayward and Raymond Massey are coming soon.

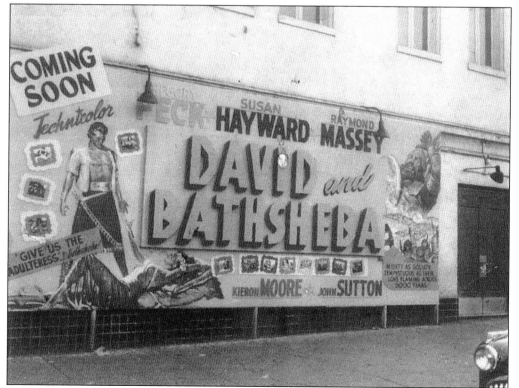

Ida Murphy Peters was the entertainment editor of *The Afro-American* Newspaper in Baltimore. She was an employee of the famous Murphy-owned newspaper for 56 years. Ida died April 13, 1996.

Seven

I BOOK IT, YOU PLAY IT

The promoters booked and promoted; the radio personalities promoted and played. Baltimore has had its fair share of history makers when it comes to radio personalities. Maurice "Hot Rod" Hulbert is known nationally for his dynamic radio persona. Rockin' Robin, Fat Daddy, and Hoppy Adams each hosted radio programs that made them legendary not only locally, but all across the nation. Dorothy Brunson and Kitty Broady blazed the trails for women in radio during their time on Baltimore's airwaves. Promoters like Nick Mosby and Elzie Street maintained close ties to these on-air icons because a radio announcer could make or break your show and/or your record.

Kathryne Holdman Broady, known to many as "Kitty," worked as a public relations director as well as an on-air personality for WANN, WWIN, WEBB, WCBM, and WBGR. She also worked as an Upton community representative for Baltimore mayors William Donald Schaefer, Clarence "Du" Burns, and Kurt L. Schmoke. She served as director of public relations for the Lafayette Market on Pennsylvania Avenue in Baltimore. Kitty Broady died May 31, 1991.

Sam Beasley was a radio personality with WWIN radio station in Baltimore. He worked with radio personality Larry Dean in 1963. Sam was the only teenage disc jockey in Baltimore during his era.

This is Aunt Pauline Lewis, radio personality. She was tops in the field of gospel music.

Dorothy Brunson was born in 1938. She landed her first important radio job in 1964 as an assistant controller of radio station WWRL in New York. In 1969 she and radio station colleague Howard Sanders opened one of the first African-American–owned advertisement agencies. In 1979 she went solo and bought WEBB radio station in Baltimore, headquartered at Clifton Avenue and Denison Street (also known as Walbrook Junction). It was located there for 20 years.

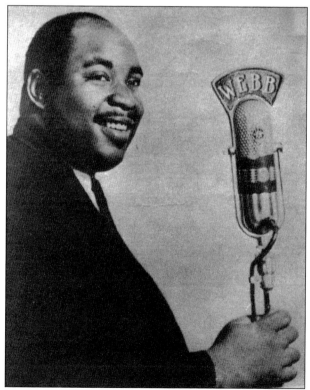

Pictured here is Rockin' Robin at the mike on WEBB Radio Station. Born Fred Robinson in New Jersey, Rockin' Robin started in radio in 1956 in Atlantic City. He traveled to Baltimore and joined WEBB 1360 AM. In 1967 he left WEBB for WWIN, where he rode the airwaves with Hot Rod, Fat Daddy, and Al Jefferson. In 1969 he returned to WEBB after James Brown purchased the station, making WEBB the first black-owned station in Baltimore. He established Premier Attractions, a concert and events promotions firm, which brought major R&B talents to the Baltimore Civic Center throughout the 1970s.

Henry Sampson is pictured in his three-piece pinstripe suit and holding his microphone while he emcees a show. He was known as the roving disc jockey and was a special friend to all the radio disc jockeys. He was also on air at WSID with Vernon Blagmond and had a program called *The House of Blue Lights*.

Kelson "Chop-Chop" Fisher was featured at WSID Radio with Bill "Sparky" Mullen and was one of the top disc jockeys in 1949.

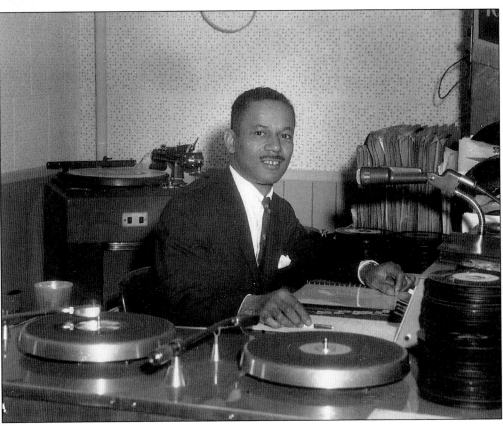

In 1951, "Hot Rod" (Maurice Hulbert) became the first full-time radio announcer on an all-white station when he joined the ranks of WITH radio. Nationally known for his quick wit and outer-space theatrics, Hot Rod and his spaceship definitely hover in radio personality history.

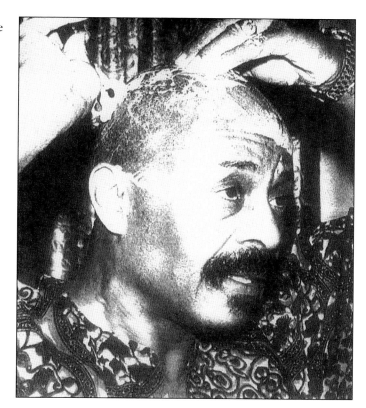

Hot Rod as a youngster is pictured with an unidentified dance partner in the 1930s.

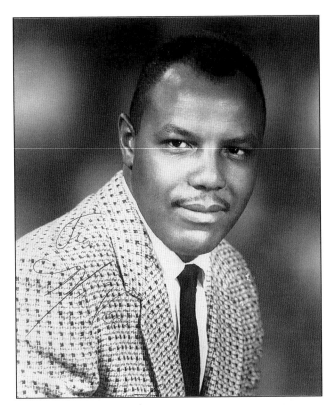

Vernon "Mr. Vee" Blagmond worked at Baltimore radio station WSID. From 1951 to 1954 he had a special program on the air called *The House of Blue Lights*. He played records to go along with love letters and dedications sent in by his listeners.

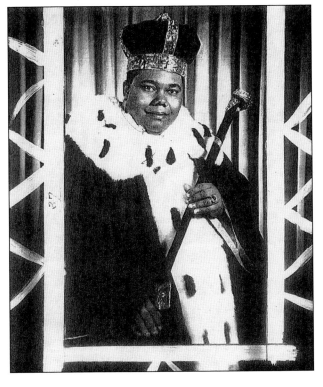

Paul "Fat Daddy" Johnson was born in Baltimore in 1938, and worked at WITH, WSID, and WWIN. He started his career spinning records in college and at the Royal Theater. He was named one of the top-five on-air personalities by *Cash Box* Magazine. (Courtesy of the *Baltimore Sun*.)

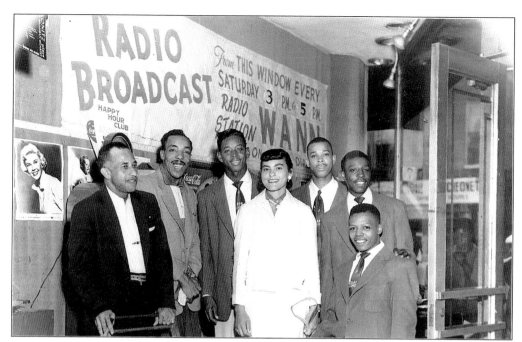

Hoppy Adams, known for his signature bowtie, was always sharp. He developed his exquisite taste in clothing after working in a haberdashery for several years. He graduated from St John's College in Annapolis, worked as a barber and a cab driver, and earned his first job in radio after he won a contest sponsored by radio recruiters. Upon Hal Jackson's urging, Hoppy took to the airwaves and the signal has never been the same. *The Hoppy Adams Show* was enjoyed as far away as Ohio, thanks to WANN's 50,000 watts. The Left Bank Jazz Society, Inc. (LBJS) was always grateful to Hoppy for his dedication to the jazz community, and he always acknowledged and praised the LBJS for their concerts and commitment to nurturing young artists. He was forever a friend to local promoters. Pictured here inside the Royal Record Store on Pennsylvania Avenue is Hoppy, second from left, during a regular live Saturday afternoon broadcast on WANN-AM.

Delbert "Dell" Pinkney Edwards (1935–1991) began a career in radio at the age of 14 with an internship under Chuck Richards, renowned radio personality. Part of the program was to answer request mail for the famous "Cupid's Corner." He free-lanced part-time as a disc jockey for Chuck Richards and worked with the late Larry Dean and the late Paul "Fat Daddy" Johnson. "Dell" became known as the only disc jockey to work seven jobs at one time. He worked for stations such as WEBB, WEAA, WTOP, WBAL-TV, WWIN, WLIF, and Channel 45-TV. He produced and hosted *Inside Thirty*, a talk show on WWIN. Dell was a friend to the entertainment world and a devoted fan of the Left Bank Jazz Society.

Walter Robert Carr Sr. (1913–1993) was referred to as the "Godfather of Night" in Baltimore. Walter came up with the idea of the *Nitelifer*, a weekly nightclub and business tabloid, in 1963. The publication and its editorial page gave him the platform he needed to get his message out to the masses. "No Johnny come lately" to the issues of civil rights, he and his wife were taken from a sound truck in Baltimore in 1941 and arrested for protesting police brutality against "colored people." The success of black liquor salesmen in Baltimore can be traced to a very successful boycott that Walter and the *Nitelifer* spearheaded in the 1960s. He was also a devoted jazz lover and did much to promote the local music scene.

Elzie Street (1927–1995) was a self-employed man. He had a passion for jazz, and it was this passion that sparked his interest in becoming a jazz promoter. Elzie booked shows at Sparrow's and Carr's Beaches and had many successful summer concerts such as Clyde McPhatter, the Drifters, Sam Cooke, Etta James, LaVerne Baker, and James Brown. Wilson's Restaurant at North and Pennsylvania Avenues featured Sunday afternoon jazz with such names as Horace Silver, Lee Morgan, Art Blakey, Miles Davis, Sonny Stitt, Art Farmer, and many others. He and his wife also owned the Royal Roost Night Club, a home to many local performers such as Fuzzy Kane's Trio featuring Ruby Glover, Ethel Ennis, and O'Donnel Levy. One also might have seen Mickey Fields and his sister Shirley, or Gene "Jug" Ammons blowing "Red Top" on his sax, or Rufus Harley playing his jazz bagpipes. At the Baltimore's Meyerhoff Theater, Elzie brought in acts such as Sammy Davis Jr., Johnny Mathis, Flip Wilson, Lola Falana, and Sara Vaughn. He was the promoter of the Atlantic City Jazz Festivals.

Robert William Matthews III (1929–1995) was a great jazz lover. He was a journalist and columnist who was widely read and appeared in *The Afro American* Newspaper for over 30 years. He was also an announcer and news director of Baltimore's WEBB radio station. Bob was also a pioneer television anchorman. He worked for NBC in New York and Washington.

Pictured here is Alfred Jerome Stewart (1941–1992). Before going to WWIN radio station, Mr. Stewart worked for the gospel station WBGR and Morgan State University. He was general manager and a university instructor.

Renowned radio personality Chuck Richards hosted a program called "Let's Spin It" on WITH. He also worked at the Royal Record Shop that used to be located next to the Royal Theater on "the Avenue."

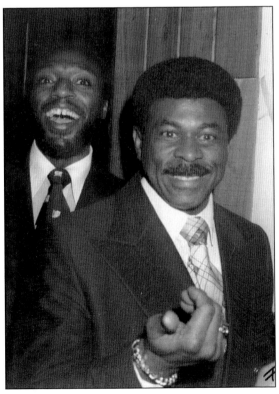

Ray Murray and Nick Mosby, promoters, are pictured here.

Eight

TAKING CARE OF BUSINESS

It was a wonderful era when African-American people celebrated their culture with dignity, love, and unfounded support for each other. Our African-American communities flourished with all kinds of businesses, from florists to bakeries; shoemakers to cleaners; doctors to lawyers; restaurants to nightclubs; boutiques to beauty salons. We all could count on each other and we looked forward to occasions that brought us together socially, as "The Avenue" often did. This chapter reminds us of the shops and stores where entertainers purchased their get-ups and get-downs, ate, bought groceries and supplies, or just stopped by to say "hi" to the businessmen and women who supported them in their artistic pursuits. Not only did the shop owner take care of business, but also they took care of the arts, the culture, and the community as a whole.

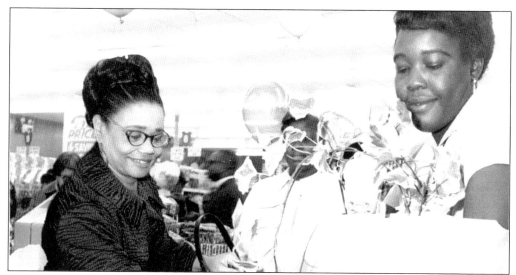

Victorine Adams (left) was the wife of Little Willie Adams, who was the owner of Club Casino. She too had an entrepreneurial spirit like her husband, as she owned and operated the Charm Center, a women's dress and accessories shop. Many of the same entertainers who played the Royal and Regent Theaters and other places shopped right up the street at the Charm Center. (Courtesy of the Henderson Collection; Peale Museum, Baltimore.)

This photograph shows the interior of the Charm Center in September 1949. (Courtesy of the Henderson Collection; Peale Museum, Baltimore.)

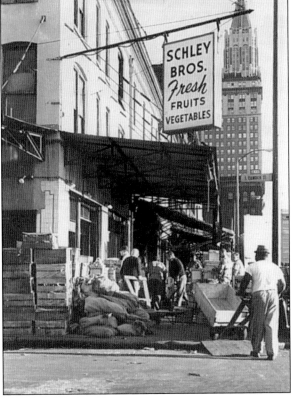

Here is a picture of Schley Brothers Fresh Fruits Vegetables stand somewhere on Pennsylvania Avenue in 1949.

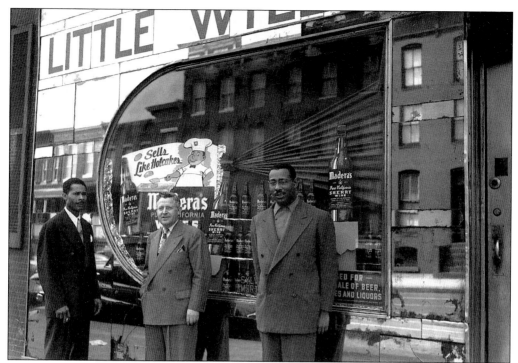

Pictured here is Little Willie's Cut Rate and Bar in April 1949 with three unidentified men in front. It was located at Druid Hill Avenue and Whitelock Street. (Courtesy of the Henderson Collection; Peale Museum, Baltimore.)

This is the McCulloh Delicatessen, with its square plate-glass windows, in a residential section of Baltimore in 1949. (Courtesy of the Henderson Collection; Peale Museum, Baltimore.)

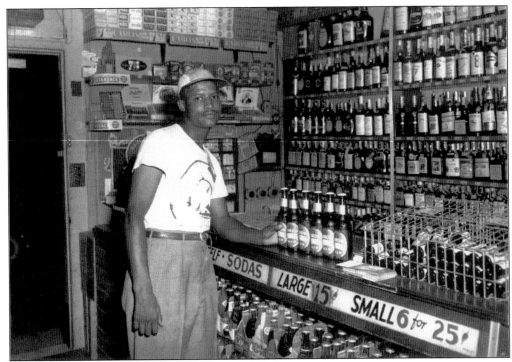

An unidentified man is pictured in a liquor store on Pennsylvania Avenue in 1950. (Courtesy of the Henderson Collection; Peale Museum, Baltimore.)

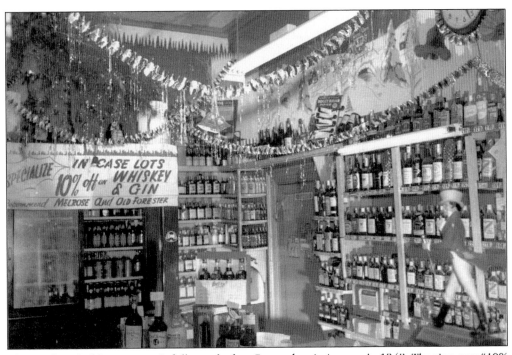

This unidentified liquor store is fully stocked on Pennsylvania Avenue in 1949. The sign says "10% off whiskey and gin." (Courtesy of the Henderson Collection; Peale Museum, Baltimore.)

Another business that thrived in Baltimore was Vince Conigliaro & Company, a fruit company. The block was full with baskets of apples, cantaloupes, white potatoes, string beans, etc.

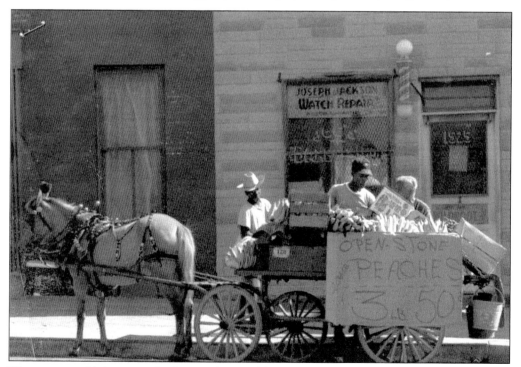

When one couldn't get to the fruit and vegetables stands, they came to patrons by horse and cart. Here patrons buy fruits in front of Joseph Jackson Watch Repair and Joe's Barbershop, 1925 Pennsylvania Avenue. His wagon is carrying a sign saying "Open-Stone Peaches 3 lbs for 50 cents or 20 cents for a lb."

From left to right are William Bradford, Frank Harrell, Mark Powell, and Jim Dorsey at Dorsey's gas station, which opened in the late 1940s.

Vendors are seen with baskets of fruits in an unidentified area of Baltimore.

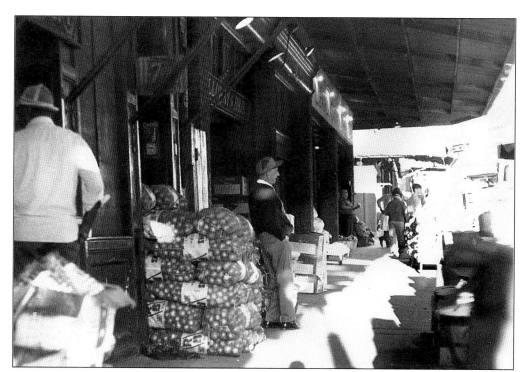

Bags of onions and potatoes are stacked against the wall at Calloway & Brothers in downtown Baltimore City in the 1940s.

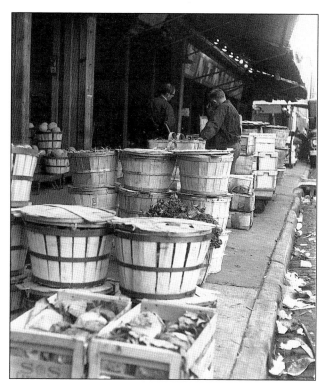

N.T. Mascao sells fresh collard greens, potatoes, and corn-on-the-cob from truck loads on the streets in the 1940s.

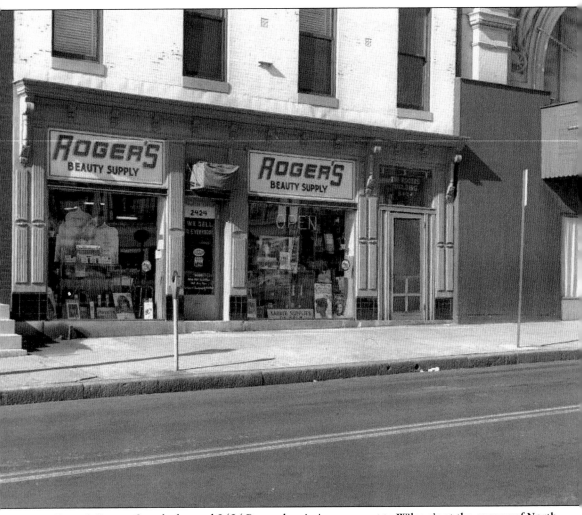

Roger's Beauty Supply, located 2424 Pennsylvania Avenue next to Wilson's at the corner of North Avenue, is seen in the late 1940s. It still stands today in the same location. Wilson's was a catered dining room with a dance hall and live entertainment. It is now the location of Arch Social Club, the oldest men's social club in the country and a private nightclub and lounge.

This is Juanita "Mom" Taylor in 1940, standing by her car across the street from the Carver Movie Theater. She was the owner of a well-known restaurant called LaPlaza, but known to her faithful patrons as "Mom's Kitchen," located in the 1400 block of Pennsylvania Avenue. She later moved to 1336 Pennsylvania Avenue in 1950, across the street from the Royal Theater, until 1971. Juanita and her husband Jack, who was known as "Pop," became purveyors of the best soul food in Baltimore. "Pop" was a chef and was known for his biscuits; "Mom's" specialty was her strawberry shortcake and hog maws and chitlins. She served chicken and dumplings only on Sundays. (Courtesy of Jacqulin Taylor-Johnson.)

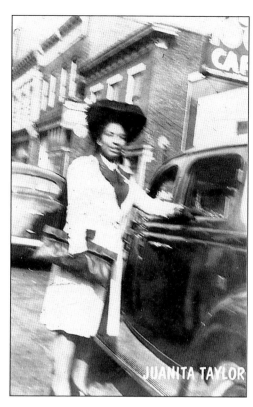

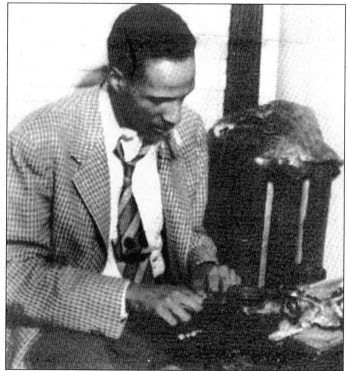

James E. "Biddy" Wood Sr., was a renowned journalist, editor, and manager of the Baltimore, Richmond, and Washington *Afro American* Newspapers. Wood went into show business professionally in the late 1960s. Among the entertainers he managed were Sallie Blair, Brook Benton, Gregory and Maurice Hines, Joe Tex, The Four Tops, and Damita Jo, who became his wife.

Clarence "Shad" Brown Sr. has been an icon of entrepreneurial success, serving and contributing to Baltimore since 1940. Inspired and influenced by great African-American contemporaries of his time, whose talents exemplified our culture, Shad had a mission to facilitate and promote positive opportunities for his community. As a young boy, his mother told him stories about her employers going on cruises and of travels to far away countries. Intrigued and awed by these tales of seafaring adventures and far-away places, he decided that he, too, would someday journey to distant lands. After several business ventures, Shad opened Shad Brown's Bail Bonds and eventually expanded the business to include a travel agency. Before integration and the advent of Atlantic City casinos, Shad Brown's Travel Agency sponsored frequent bus tours to Atlantic City. He expanded his itinerary to include tours of most of the United States, Canada, Europe, Bahamas, and Bermuda. He became friends with the late great Count Basie and often visited the Count at his home in the Bahamas. Other celebrity friends included Redd Foxx, Dinah Washington, D.J. Hot Rod, and Baltimore's own Slappy White. Shad Brown Sr. is truly one of Baltimore's legendary entrepreneurs with more than five decades of successful ventures.

Nine

THE MEETING IS CALLED TO ORDER

Social organizations have always been a conduit for the entertainment industry. Meetings and gatherings, banquets and fundraisers required good, solid entertainers. For Baltimore, the Arch Social Club, the Young Pharaohs of the Sphinx Club, and the Left Bank Jazz Society were dedicated to keeping our arts heritage alive. Many entertainers received their first audience through these kinds of organizations and are forever indebted to the groups. Premiering at a Left Bank Jazz Society concert at the Famous Ballroom opened doors for many hungry musicians and elevated their star power. To support these groups could mean the difference between a quick sensation of success or an abundance of achievement and accomplishment.

Some of the Young Pharaohs of the Sphinx Club are pictured in the 1940s. The members were (in no particular order) Andrew "Ratty Billy" Johnson, Arthur Butler, Harold Darden, William Washington, Alonzo Tweed Rogers, Charles Presbury, Anderson Booker, Robert Torrence III, Walter Carr Jr., William Day Jr., Herbert Chase, James Glover, Vertis Johnson, Carroll Gibson, Samuel Adams, and Eddie Buckson.

These are the Pyramids as they appeared in 1958. From left to right are Eugene "Specs" Johnson, Donald Meritt, James Rogers, Donald Bedford, Donald Jackson, Kelson "Chop Chop" Fisher, Charles Bruce, Alfred James Foote, Herbert Garnes, Arthur Myers, Nelson Taylor, and Napoleon Clark. Joseph Dixon is not shown.

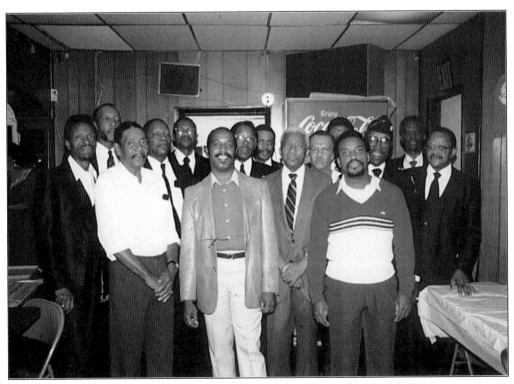

Here is the pride of Baltimore's Elks Lodge. Members are pictured in the 1970s.

Officers of The Left Bank Jazz Society, Inc.

BENNY KEARSE

Benny Kearse is Chairman of the Board of Directors of L.B.J.S. of Baltimore, and its current President. Mr. Kearse has held this position in Left Bank for 6 of its 11 years of existence and is probably the most knowledgeable authority on Baltimore's jazz history. He has written innumerable articles on jazz in Baltimore and has supervised or coordinated concerts in the metropolitan area for over a decade. In 1964 Mr. Kearse spearheaded the formation of the Left Bank Jazz Society, along with present charter members Vernon Welsh and Charles Simmons. Using experience gained as an officer of the Interracial Jazz Society (1955-58) he set the wheels of L.B.J.S. in motion, becoming its first president. Downbeat associates cited Mr. Kearse in 1966 for leadership as president of L.B.J.S. In 1969 Mr. Kearse and the Society were honored by receiving the prestigious Afro-American Honor Roll plaque. Within the jazz society Mr. Kearse has held the following positions: Coordinator of all concerts and events; Chairman of the third annual Eastern Conference of Jazz Societies, 1969; Chairman of the Tenth Anniversary Celebration Committee, 1974; Chairman of the Public Relations Committee; Vice-President; and Secretary.

VERNON WELSH

e of the thirteen founders of L.B.J.S. in 1964, Vernon Welsh has aired the Entertainment Committee since then, negotiating contracts h artists or their agents. Other positions held: 2 terms as President; erms as Vice-President; Chairman of a 27-college lecture committee hich resulted in an invitation to produce and host WBJC-FM's first z program, now in its 8th year, and increased to 3½ hours); M.C. at st L.B.J.S. concerts; and handles the sound system at the concerts.

LEON MANKER

Leon Manker joined L.B.J.S. in 1964, a former member of the Interracial Jazz Society (1955-57). He has served in several positions, including Recording Secretary, Financial Secretary, Treasurer, and President. During his presidency in 1968, auxiliary chapters of Left Bank were establshed in the Maryland Penitentiary and the Maryland House of Correction in Jessup, Maryland. Mr. Manker is currently serving as Financial Secretary, and also serves as Chairman of the Prison Liaison Committee.

JAMES HATCHER

mes Hatcher is one charter member of Left Bank who loves to party, s is evidenced by his long service on the Party Committee. Other ositions held are; Business Manager (1968-69); Board of Directors ember; and President (1970-71). Mr. Hatcher is currently serving as istorian, Librarian, Parliamentarian, Chairman of the Party mmittee, and is serving his third term as Treasurer.

JUDY WEBBER

In 1967, through a love for jazz, Judy Webber joined Left Bank and became one of its most dedicated workers. She has worked on the Public Relations Committee in production of yearbooks and promoting the club at the Baltimore City Fair. Much of her photography has been contributed to Left Bank. A past Corresponding Secretary, she is currently serving her fourth term as Recording Secretary.

Left Bank Jazz Society, Inc. was formed in 1964 by a group of young men who met in a south Baltimore nightclub to discuss the plight of jazz in the city. Among those present were Benny Kearse, Vernon Wolst, Phil Harris, Charles Simmons, Joseph Simmons, Eugene Simmons, Gilbert Rawlings, Earl Hayes, Benjamin Kimbers, Otts Bethel, John O. Thompson, Orlando Pino, Glen McGill, James Dunn, Harold Bell, Robert Brice, Charles Brice, and Lionel Wilson. The first elected officers were Benny Kearse, president; Phil Harris, vice-president; Lionel Wilson, secretary; Joseph Simmons, financial secretary; Charles Simmons, business manager; and Benjamin Kimbers, treasurer.

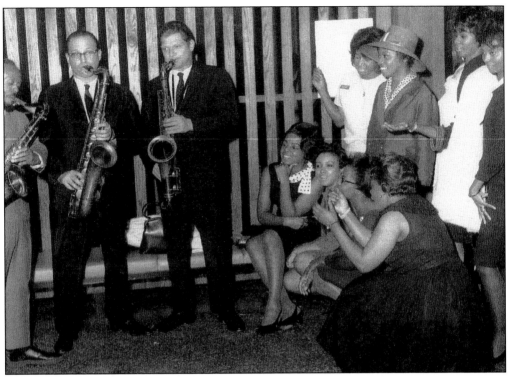

The Left Bank Jazz Society hosted an outdoor jazz concert.

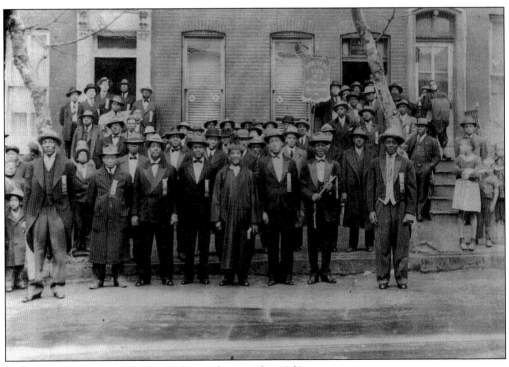

This is a picture of Arch Social Club members in the 1940s.

History of the Left Bank Jazz Society, Inc.

The Left Bank Jazz Society, Inc., was formed in 1964 by a group of young men who met in a South Baltimore night club to discuss the plight of jazz in the city. Among those present were Benny Kearse, Vernon Welsh, Phil Harris, Charles Simmons, Joseph Simmons, Eugene Simmons, Gilbert Rawlings, Earl Hayes, Benjamin Kimbers, Otts Bethel, John O. Thompson, Orlando Pino, Glen McGill, James Dunn, Harold Bell, Robert Brice, Charles Brice and Lionel Wilson. From their discussion came the idea of forming an organization devoted to perpetuating and permeating an awareness of jazz as an art form through organized activities such as lectures, concerts, sessions and field trips to festivals and night clubs where jazz is featured. Within the next two weeks the group met several times to draw up their final constitution and select an appropriate name. On their final meeting they elected officers. They were: Benny Kearse, President; Phil Harris, Vice-President; Lionel Wilson, Secretary; Joseph Simmons, Financial Secretary; Charles Simmons, Business Manager; and Benjamin Kimbers, Treasurer.

The first project launched by the organization was its weekly concert series, which features outstanding local, national and international jazz performers. These concerts have been instrumental in attracting thousands of new jazz converts. The first concerts were held at the Al-Ho Club, 2559 Frederick Avenue, beginning August 8, 1964. After about 25 weeks L.B.J.S. moved its weekly concerts to the more spacious Madison Club at Madison and Chester Streets, where it conveniently accomodated its vast following every Sunday. Two fires which gutted the entire building necessitated moving the concerts to its current location at the Famous Ballroom, 1717 N. Charles Street, in the heart of downtown Baltimore.

During the years of its existence the Left Bank Jazz Society moved toward its goals in striving to create a social and cultural climate in which jazz can better be enjoyed and advanced; and to reach audiences that might not otherwise be reached. The Society tries to develop and maintain a rapport between the musician and his audience, fulfilling the needs of both. Through a variety of cultural outlets, L.B.J.S. strives to bring about opportunities to learn more about jazz, its evolution and its relevance.

Some of the activities being promoted by the Left Bank Jazz Society are:

A. The weekly jazz concert, which features internationally famous jazz musicians every Sunday from 5-9 p.m. at the Famous Ballroom, 1717 N. Charles Street, in the heart of downtown Baltimore.

B. Participation in the Eastern Conference of Jazz Societies from 1967 until the present.

C. Establishment of the L.B.J.S. Jazzline (945-2266), a 24-hour taped message which lists coming jazz

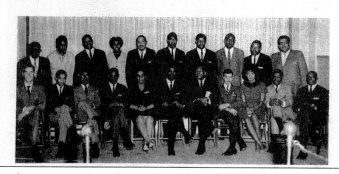

Inspired by his military post in Paris during the 1960s, native Baltimorean Lionel Wilson decided he wanted to start a jazz sanctuary like those he became enamored with in Paris—France's Left Bank. His mother Dottie, a very well-known starmaid of Baltimore's entertainment scene, assisted him with obtaining the Left Bank Jazz Society's first home atop a bar in south Baltimore on Washington Boulevard. He called this place the Left Bank Room and it was a simple venue that played jazz records and provided a place for jazz lovers to socialize. The tiny room could barely hold 40 people. Benny Kearse and Vernon Welsh, both members of the very controversial Interracial Jazz Society (IJS), which was established during the late 1940s during the height of segregation, frequented the Left Bank Room and inspired Lionel Wilson and Jamal Simmons, his venture partner, to establish an organization like the IJS. The Left Bank Jazz Society (LBJS) was born. They began hosting concerts and very quickly outgrew their tiny home. They relocated to the Al-Ho Club on Franklintown and Frederick Roads, where owner Alma Holiday allowed them to have their meetings upstairs and their concerts downstairs. Soon, LBJS's popularity blossomed and had to be moved to the Madison Club. The concerts quickly became standing-room-only events. Initially they hosted only local musicians, allowing them to share their knowledge and craftsmanship with the audience. As jazz swept the city, LBJS invited outside artists, mostly from New York City. Mr. Ray Pino assisted with the booking of these jazz legends; as a Brooklyn nightclub owner, he managed to negotiate artist participation for little to no monetary compensation. Therefore, LBJS became popular among New York City's jazz arena. The LBJS eventually moved to the Famous Ballroom on North Charles Street and stayed there through the height of its existence. (Courtesy of Benny Kearse Archives at Sojourner Douglas College.)

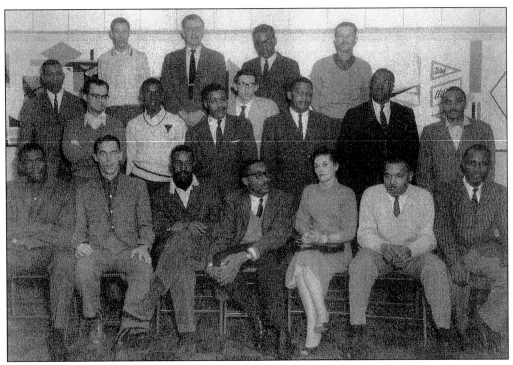

This is a photograph of the Interracial Jazz Society. (Courtesy of Benny Kearse Archives at Sojourner Douglas College.)

Ray Pino (left) and Barry Harris (right), an invaluable LBJS resource, brought in most of the outside musicians that performed their four-hour stint at the Left Bank. (Courtesy of Benny Kearse Archives at Sojourner Douglas College.)

Vernon Welsh, who recorded the LBJS concerts, and the officers of the LBJS arranged for Morgan State University to archive the live, one-of-a-kind concerts, which are now available in major record stores across the country. (Courtesy of Benny Kearse Archives at Sojourner Douglas College.)

John Fowler is a member, officer, and past president of LBJS. (Courtesy of Benny Kearse Archives at Sojourner Douglas College.)

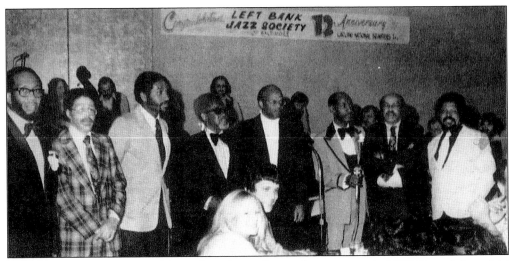

Special friends and patrons of the Left Bank Jazz Society Inc. are seen in 1977. From left to right are Judson Hughes, Frank Maddox (*Time Printer*), Frederick I. Douglass (*Sun Paper*), Walter Carr Sr. (*Nite Lifer* Magazine), Bob Matthews (*The Afro American* Newspaper), Berry Kearse, Milton Allen, Benny Pope, and Ken Stein (WBJC-FM radio general manager).

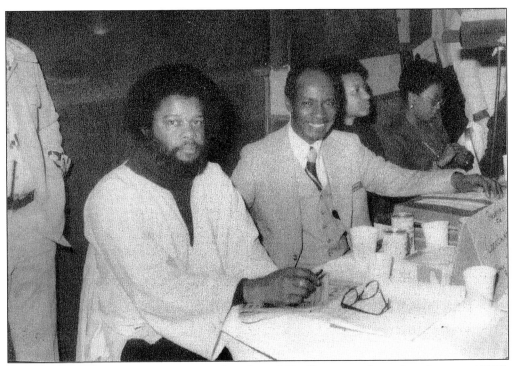

Dr. Charles Simmons and Benny Kearse, founding LBJS officers, are shown hanging out at LBJS. (Courtesy of Benny Kearse Archives at Sojourner Douglas College.)

Ten

SHOWING OFF

Procession is an age-old form of celebration. In the African-American community, it is a staple of society. What would we be—and what would we do without—the parade? And how we hated to see the live music and shaking and strutting come to an end. See the majorettes and drummers give up the sweat in 30-below temperatures. Watch them melt down in 107 degrees in the shade. Whether hot or cold these dedicated artists showed up to give the people something to talk about. The marching bands in Baltimore allowed the youth to demonstrate their spunk and creativity. This was one of the main extracurricular outlets for the young people in the community. Get ready to run outside—the high steppers are coming through!

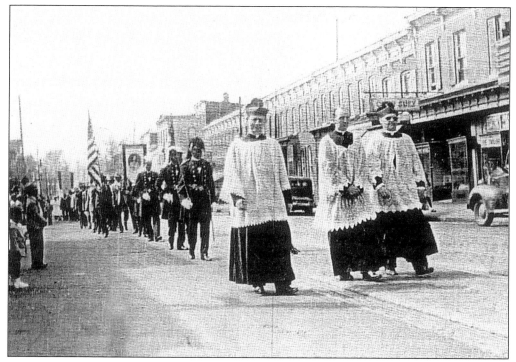

St Peter Claver Catholic Church is represented in the May Procession Parade in 1946 on Pennsylvania Avenue and Gold Street.

Evelyn Moody, founder and executive director of the Firebirds Marching Band and Majorette Ensemble, started in a marching group formed by her mother, Mrs. Sarah Cross. She had a passion for baton twirling and mastered the craft from intensive study of a book she checked out at the Enoch Pratt Free Public Library in West Baltimore where she grew up. When the governing body of her mother's Harlem Park Cameros changed, she branched out to form her own crew of baton twirlers. Michael Vass, a close friend and confident, came up with the name "Firebirds" in order to be inviting to both male and female participants. Mrs. Moody executed duties as mother, counselor, trainer, seamstress, booking agent, and chauffeur. The group, like most marching groups, maintained themselves through parental support and ongoing fundraisers like raffles, dinners, candy sales, and trips. The Firebirds thrived until 1984 without any formal sponsorship. As testimony to cultural commitment and community responsibility, Mrs. Evelyn Moody has contributed selflessly and tirelessly to this black history legacy. (Courtesy of Evelyn Moody.)

Mrs. Sarah Cross, seen here standing in her dining room, inspired her daughter Evelyn to form the Firebirds. She was director of a marching band that had several different names over the years including the Harlem Park Cadets and Cadetters, the Harlem Outriders, and the Harlem Park Camaros.

The Outriders, Mrs. Cross's group, practice for the upcoming Elks parade in Mrs. Cross's basement, c. 1961. (Courtesy of Evelyn Moody.)

Pictured here in 1963 are the first five young ladies that Ms. Moody trained as baton twirlers. The group used oatmeal boxes covered in satin as their first head toppers because money was not plentiful. (Courtesy of Evelyn Moody.)

Arnett Evans challenged Evelyn to add a drum line. He had been a mentor and teacher of the Falcons Drummer Corp, a group that included Kweisi Mfume, former United States Representative and current president of the NAACP. After the drumline was added, Mrs. Moody added a pom-pom squad and a color guard, and flag maestros began winning competitions up and down the east coast. Mrs. Moody prided herself in assuring that the costumes were always different from everyone else's. (Courtesy of Evelyn Moody.)

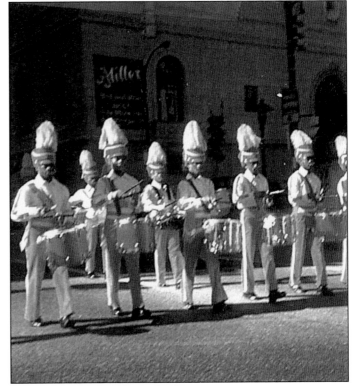

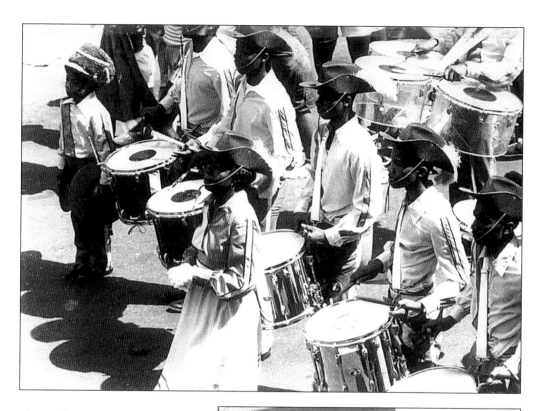

The Firebird drumline is being led by drum major Mrs. Anna Hart. Mrs. Moody's son, a precocious five years old, is managing his cymbals at the far left. (Courtesy of Evelyn Moody.)

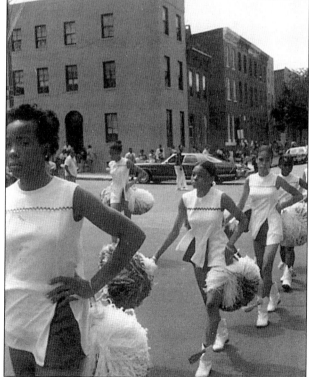

The Jackson Steppers, another local marching group, is seen strutting their stuff in the mid-1970s. They are marching down Baltimore's Division and Bloom Streets off of Pennsylvania Avenue. (Courtesy of Evelyn Moody.)

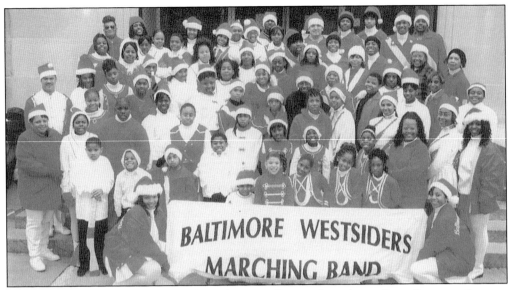

The Baltimore Westsiders, another legendary parading outfit and guardian of our youth, were spawned from the Westside Cadets in 1969. Established by community organizer Mr. Jeff Pitts, the Westside Cadets were formed in the early 1960s. As chairman of the Winchester Improvement Association in 1969, Mr. Pitts asked the children what extracurricular activity they desired to develop. The marching band was the unanimous response. Mr. Pitts had a plethora of experience with youth organizations as a director of the Cub Scouts, the Boy Scouts, and Little League Baseball. The Winchester Armory, on the corner of Winchester Street and Braddish Avenue in West Baltimore, has served as the group's headquarters since their inception and is still their home. The group practices two times each week. The Westsiders stress scholarship, citizenship, and brotherhood. (Courtesy of Mr. and Mrs. Jeff and Dorothy Pitts.)

Here are a Westsider twirler and her mother. Parental support is crucial to the success of these bands and for the Westsiders, parental guidance is available abundantly.

Eleven

THE WORD ON THE STREET

The streets—just the place where the people walked and talked and greeted one another. Where the arabbers and their horses found elbowbenders just leaving the saloon at 6 or 7 a.m. "Have an apple on me, my friend," an arabber may say to an inebriated patron as he stumbled his way home. Pennsylvania Avenue knew her arabbers, neighbors, friends, patrons, lovers, and cousins. The streets are where everyone shared the gossip, the truth, and the latest. And we all knew that the word on the street was the only true word.

Shoppers are strolling down the 1700 block of Pennsylvania Avenue in 1940s. (Courtesy of the Center for Cultural Education.)

The term "arraber" is unique to Baltimore's black culture. The word describes black men and boys who sell fresh fruits, vegetables, and meats from their horses and wagons as they ride through the streets advertising their wares and alerting their customers in a hollering, sing-song rhyme and rhythm, "Holler, holler, holler till my throat gets sore. If it wasn't for the pretty girls, I wouldn't have to holler no more! I say, Watermelon! Watermelon! Got 'em red to the rind, lady." Arrabbers are pictured here *c.* 1960.

Benjamin Pope was a renowned promoter who worked with Elzie Street booking the top jazz artists in Baltimore, Washington, and New York.

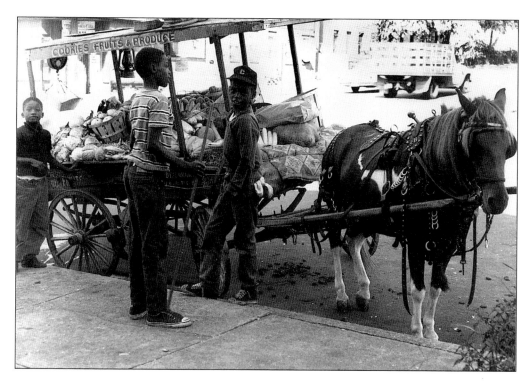

Young arabbers made a living
selling fruits and vegetables.

Biddy Wood and Damita
Jo's daughter, Stephanie, are out
for a stroll.

Dedicated to serving the community, Jeff Pitts is seen here with the Belmont Braves little league team.

Gloria Thomas was a model and head of her own School of Charm. Here she models for the Providence Hospital Fundraiser. (Courtesy of Robert O. Torrence.)

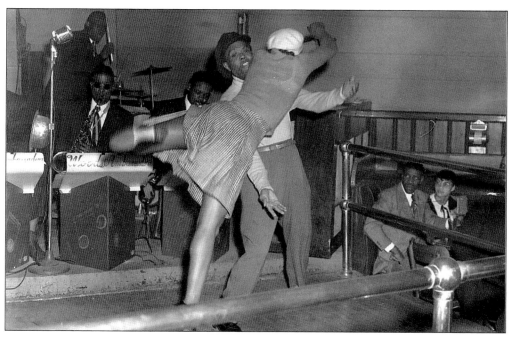

Two unidentified people are seen jitterbugging across the dance floor of one of the dance halls on "The Avenue."

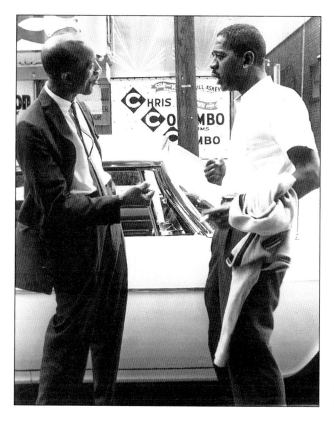

Here are "Eggy Boyd" and "Tillie" of the Sphinx Club hangin' out, exchanging the "word" on the Avenue.

BIBLIOGRAPHY

Arch Social Club. *The 90th Anniversary Celebration, March 17–23 2002*. Baltimore, Maryland.

Barker, Danny and Alyn Shipton, editor. *A Life In Jazz*. Oxford: Oxford University Press, 1986.

Bogle, Donald. *Brown Sugar: Eighty Years of America's Black Female Superstars*. Cambridge, Massachusetts: Da Capo Press, Inc., 1980.

Donovan, Richard K. *Black Musicians of America: A Major Influence of Over 200 Years*. National Book Company, 1991.

Goldberg, Marv. *More Than Words Can Say: The Ink Spots and Their Music*. Lanham, Maryland: Scarecrow Press, 1998.

Goldberg, Marv. "The Orioles." *Marv Goldberg R&B Notebooks*. http://home.att.net/~marvy42

Hinton, Milt and David G. Berger. *Bass Line: The Stories and Photographs of Milt Hinton*. Philadelphia: Temple University Press, 1989.

Igus, Toyomi, Veronica Freeman Ellis, Diane Patrick, and Valerie Wilson Wesley. *Black Heroes Volume II: Great Women in The Struggle*. East Orange, New Jersey: Just Us Books, Inc., 1991.

"Illinois Jacquet," Biography Resource Center, Gale Group Inc., 2001.

Kravetz, Sallie, and Ennis, Ethel. *The Reluctant Jazz Star*. Hughes Enterprise/Gateway Press, 1984.

Left Bank Jazz Society, Inc. yearbooks, 1970 and 1977, "The Baltimore Jazz Scene," Baltimore, Maryland.

"The Life and Music of Chick Webb" article, *Duke University Music History Web Site*, www.music.duke.edu/jazz

Also, see www.culturaled.org and www.drummerworld.com.

INTERVIEWS

Alvin Brunson, historian, CEO of The Center for Cultural Education, Inc., January 2003.

David Coleman, Coleman Music Researchers, Atlanta, Georgia, March 2002.

Timothy "Tiny Tim" Harris, Baltimore, Maryland, April 1993.

Stuart Hudgins, African-American history researcher and consultant, June 2002.

Henry Sampson, radio personality, Baltimore, Maryland, April 2002.

James "Biddy" Wood, journalist and music promoter, June 2002.

Virginia Woodley, jazz singer, Baltimore, Maryland, July 2002.